IMAGES
of America

COLD SPRING
HARBOR

IMAGES
of America

COLD SPRING
HARBOR

Robert C. Hughes

ARCADIA
PUBLISHING

Published by Arcadia Publishing
Charleston, South Carolina

Printed in the United States of America

Library of Congress Control Number: 2014932351

For all general information, please contact Arcadia Publishing:
Telephone 843-853-2070
Fax 843-853-0044
E-mail sales@arcadiapublishing.com
For customer service and orders:
Toll-Free 1-888-313-2665

Visit us on the Internet at www.arcadiapublishing.com

*To all those who have worked and continue to work
to preserve and share our community's history;
and to Priscilla, my first read, my first everything*

CONTENTS

ACKNOWLEDGMENTS

Preserving local history is a group effort. Cold Spring Harbor is fortunate to have several organizations and individuals who have worked to discover, preserve, and share our community's history. This book would not have been possible without the efforts of earlier residents, such as Harriet and Andrus Valentine, Estelle Newman, and Leslie Peckham, who worked to uncover the history of Cold Spring Harbor and share their discoveries with us.

Many of the fruits of their labors have been preserved at the Huntington Historical Society, which has been collecting and saving artifacts, documents, and most important for this book, photographs of our town's past. Special thanks to archivist Karen Martin and the late Mitzi Caputo, the longtime photograph curator.

Closer to home, the Cold Spring Harbor Whaling Museum has also played a very important part. Originally established to preserve Cold Spring Harbor's whaling heritage, the museum has expanded its scope beyond the brief period of the whaling days in Cold Spring Harbor. Its publications over the years—including, most recently, Terry Walton's book *Cold Spring Harbor: Rediscovering History in Streets and Shores*—have proven very helpful in completing this project.

Tom and Judy Hogan, who have done so much to restore and preserve Cold Spring Harbor's architectural heritage, have also contributed greatly to the preservation of our local fire department's history through the Cold Spring Harbor Firehouse Museum.

The fascinating history of the Cold Spring Harbor Laboratory was well told by Elizabeth Watson in her book *Houses for Science: A Pictorial History of Cold Spring Harbor Laboratory*, which is also a terrific source for the early history of the Cold Spring Harbor Fish Hatchery.

The local history collection at the Cold Spring Harbor Library, curated by Marie Horney, is another underappreciated source of materials. Thanks are also due to the Society for the Preservation of Long Island Antiquities and the Cold Spring Harbor School District.

Local residents who have shared their photographs and stories include Jennifer Hayes, Max Karafian, Kenneth Pritchard, Scott Bowden, Margaret Norton, and William Norton.

Finally, thanks to Toby Kissam for reading over the text of this book to ensure that it makes sense and Claudia Fortunato-Napolitano for her proofreading assistance.

INTRODUCTION

Water is the defining characteristic of the place now called Cold Spring Harbor. To the indigenous inhabitants, it was known as Wawepex, or "at the good little water place." The European settlers of the 17th century named the area after its abundance of freshwater springs. The word *harbor* was added in 1826 to avoid confusion with the town of the same name on the Hudson River (throughout the 19th century, most locals continued to use the two-word name). The name reflects the essential role that water—both fresh and salt—has played in the area's history. The freshwater springs provided drinking water, while the stream flowing from the south provided power for local mills. The harbor provided an outlet for trade up and down the East Coast and a starting point for whaling voyages to the far side of the globe.

Even the most disinterested resident knows that Cold Spring Harbor was a whaling port. But the whaling period was relatively brief, lasting just over a quarter century, from 1836 to 1862. There is far more to Cold Spring Harbor than whaling.

Cold Spring Harbor has been inhabited for thousands of years. Unfortunately, other than some arrowheads, tools made from animal bone, hide scrappers, and pottery shards, little evidence of pre-European settlement survives. For that matter, much of the early European settlement is also unknown. The community is a hamlet within the town of Huntington and was the western edge of Huntington's First Purchase in 1653.

Within 10 years of the First Purchase, at least three permanent homes had been established in Cold Spring Harbor: Jonathan Rogers's log house, on the east side of what is now Harbor Road about a half mile south of the head of the harbor; the Rudyard house, on the north side of Main Street just before the intersection with Goose Hill Road; and the Titus house, on the east side of Goose Hill Road across from what is now Titus Lane.

As farms became established, the need for a mill to grind grain was recognized. In order to avoid the need to bring their grain to mills in either Huntington or Oyster Bay to be ground, permission was sought to build a gristmill in Cold Spring Harbor. After two unsuccessful attempts by others, John Adams, in 1682, built a dam across the Cold Spring River, an impressive name for the small stream that runs north through the valley from the present site of the railroad station to the harbor. On this dam, Adams built both a gristmill and sawmill. The gristmill was not successful; the sawmill was.

In 1700, Benjamin Hawxhurst built a woolen mill near the present site of the Cold Spring Harbor Fish Hatchery. Later, in the early 19th century, the Jones family operated two very successful woolen mills. The upper woolen mill was located upstream on the site of the 1682 mills, at the southeast end of St. John's Pond. This mill was for weaving. The lower mill was located on the southwest side of the harbor, near the entrance to the Cold Spring Harbor Laboratory property. It was powered by water fed to the site via a wooden pipe carried over the road on a trestle from a small pond on the south side of the highway, partway up the hill. The lower mill was used for

spinning. Together, the two woolen mills produced broadcloth, blankets, and coverlets. Starting in the 1870s, the upper mill was used by George W. Earle as a sawmill and organ factory.

In 1782, Richard Conklin built a paper mill near the intersection of Main Street and Shore Road. Finally, in 1790, the Hewlett family built a gristmill on the east side of the harbor, about a quarter mile from the head of the harbor. This mill was powered by water from St. John's Pond that ran through a canal between the road and the harbor. The mill burned down in 1921, but traces of the canal can still be seen today.

Cold Spring Harbor was made a port of delivery by an Act of Congress on March 2, 1799. A surveyor of customs was appointed, who had the "power to enroll and license vessels to be employed in the coasting trade and fisheries, and to enter and clear, and grant registers and other usual papers to vessels employed in the whale fisheries." When US Customs Districts were reorganized in 1913, the Cold Spring Harbor office was shut down.

Coastal trading was a thriving activity into the early 20th century. Small shipyards produced the schooners needed to transport goods not only from Cold Spring Harbor to New York City, but also up and down the East Coast, to the West Indies, and beyond. In the 1840s, typical cargo included rice, sugar, cigars, logwood, mahogany, coffee, palm oil, and ivory. In later years, coal, sand, and gravel were typical cargos. As an indication of the scope of coastal trading, in 1883, there were 99 ships registered from Cold Spring Harbor.

The woolen mills and the gristmill were two of the enterprises run by the Jones family. The gristmill came into the Jones family through the marriage of John Jones to Hannah Hewlett. The five sons of John and Hannah Jones—especially John Hewlett Jones and Walter Restored Jones—were the leading entrepreneurs in Cold Spring Harbor's early history. In addition to their mills, they operated a general store near the gristmill, a shipyard on the east side of the harbor, and a barrel factory on the west side of the harbor. The bungs used as stoppers on the barrels gave rise to the name Bungtown. In order to get their various products to market, John H. and Walter R. Jones incorporated the Cold Spring Steam Boat Company in 1827, built a dock on the east side of the harbor, and, later, procured the steamboat *American Eagle* to transport their goods to the New York City market.

By the 1830s, foreign competition had undermined the profitability of the woolen business. In 1836, the brothers decided to expand their business ventures to include whaling. At first, they personally owned the whaling ships, but they later incorporated along with other prominent citizens of Cold Spring, Huntington, and Oyster Bay. From 1836 to 1862, nine ships sailed from Cold Spring Harbor, all on voyages lasting up to two years. Wool from the local mills, barrels from Bungtown, produce and meat from local farms, and other local products were used to outfit the ships for their months-long journeys to as far away as Alaska. The venture was successful, but the deaths of Walter R. Jones (in 1855), and John H. Jones (in 1859), as well as the discovery of petroleum in Pennsylvania in 1859, led to the inevitable demise of Cold Spring Harbor's small whaling industry.

The economic activity spurred by the whaling ventures was soon replaced by tourism, which is still a mainstay of the local economy. At the same time, shipyards, a marine salvage yard, sail makers, and blacksmiths continued Cold Spring Harbor's industrial traditions.

World-famous panorama artist John Banvard settled in Cold Spring Harbor in 1852. Banvard made a fortune exhibiting his half mile–long painting of the Mississippi River. Audiences would be seated in a specially built auditorium while canvases on either side of the room were advanced from one spool to another, to give the illusion of floating down the river. After a successful European tour, which included a private viewing for Queen Victoria, Banvard built a castle-like home reportedly inspired by Windsor Castle, which he named Glenada in honor of his daughter Ada.

The home was later converted into a luxurious summer resort hotel, which was joined by two others, Forest Lawn, next to the Glenada, and Laurelton, on the west side of the harbor. Less wealthy visitors could stay at Van Ausdall's Hotel. Day-trippers by the thousands took steamboats out from New York City to visit local picnic groves along the harbor's shores. Some wealthy New Yorkers built homes of their own overlooking the harbor.

In the 1880s, the old factory buildings on the west side of the harbor were put to new uses. First, in 1883, New York State saw the advantages of the area's freshwater springs in operating a fish hatchery to raise fish to stock local lakes and rivers. A few years later, the Brooklyn Institute of Arts and Sciences established a field station on the harbor's western shore. That small field station has now grown into one of the leading genetics institutions in the world.

Close proximity to New York City, of course, meant that suburbanization was inevitable. The trend began slowly in the 1920s but was temporarily halted by the Great Depression in the 1930s. It resumed in full force after World War II. This explosive growth, not only in Cold Spring Harbor but throughout the town of Huntington, led directly to the establishment of what is now one of the community's most distinctive assets: its school system. Originally, there were four separate local school districts, with students who wished to continue on to high school attending Huntington High School. In 1958, when Huntington High School stopped accepting out-of-district residents, the Cold Spring Harbor and Lloyd Harbor districts banded together and built their own high school, which is now one of the top-rated schools in the country.

One

COLD SPRINGS

As its name implies, Cold Spring Harbor is defined by water. The area's freshwater springs sustained early settlers, while the harbor provided a link to the outside world. Water was also the focus of residents' livelihoods for much of Cold Spring Harbor's history. The river that ran north into the head of the harbor was dammed to create a series of picturesque lakes. But the dams were not built to enhance the scenery; they were built to provide power for the settlers' mills. The wealth generated by the mills helped finance Cold Spring Harbor's whaling ventures.

Water also provided a means of connecting with neighboring communities in a time when roads were little more than narrow, rutted dirt paths that would wash out after a heavy rain. Settlers built ships on the shores of the harbor, which then carried cargo to the New York City markets and up and down the East Coast. As these water-dependent industries waned, Cold Spring Harbor's waters were appreciated for their scenic value. Gilded Age New Yorkers flocked to Cold Spring Harbor, either for the day or for extended stays of a week or more, and eventually, many settled here. The water, once vital for the local economy, is now a cherished recreational resource.

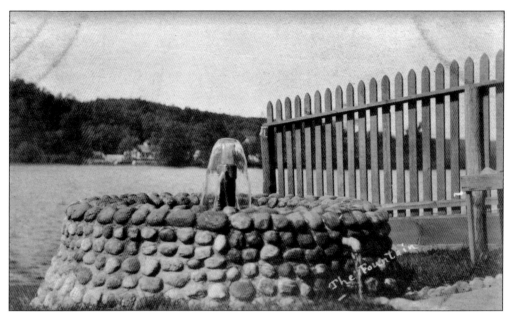

In 1902, Joshua T. Jones had this fountain installed next to the harbor opposite Thespian Hall, near where the Veterans Fishing Station is today. It was fed by Jones's flowing well on the east side of the street and was meant for use by both people and horses. Two years later, he installed a similar well on the east side of St. John's Lake. (Courtesy of the Huntington Historical Society.)

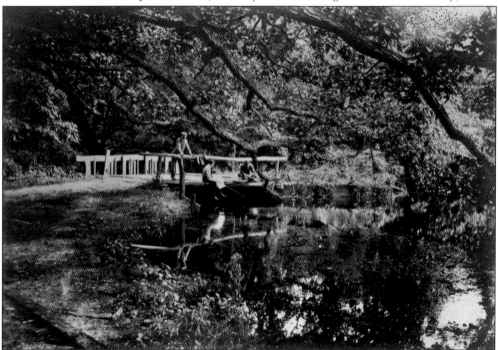

The Cold Spring River was dammed to provide power for the local mills. But the resulting lakes also provided a spot for fishing, or just admiring the view from the bridge. Known as Jones' Bridge, it crossed over the upper dam between St. John's Lake and the next lake to the south, near the site of the original gristmill. (Courtesy of the Huntington Historical Society.)

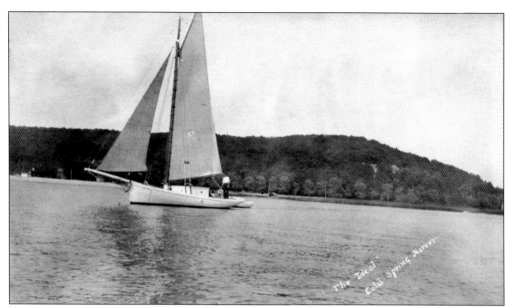

Water was for recreation as well. Capt. Benjamin Doty was a housepainter and the owner of the *Ideal*. In the early years of the 20th century, he would take young people, including those from the biological labs, out on his boat for cruises around the harbor or to see the International Motor Boat races held in Long Island Sound or Huntington Bay. (Courtesy of the Cold Spring Harbor Whaling Museum.)

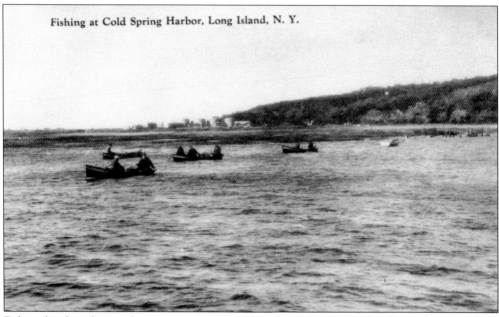

Fishing has long been a favorite pastime in Cold Spring Harbor. Here, fishermen head out from the inner harbor, probably on boats rented from Powles' Marina. The Mobil oil tanks on Shore Road, which were demolished in 2005, can be seen in the distance. (Courtesy of the Cold Spring Harbor Whaling Museum.)

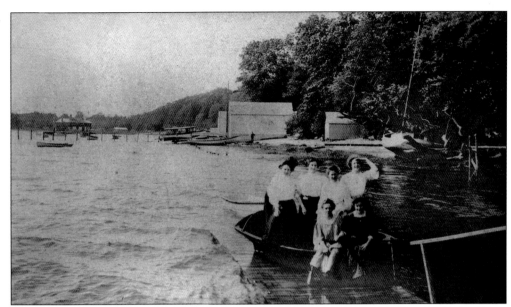

A group of women prepares for a day on the water on the harbor's western shore. The buildings behind them, standing on Shore Road, are the oyster houses of Samuel Walters. (Courtesy of the Cold Spring Harbor Library.)

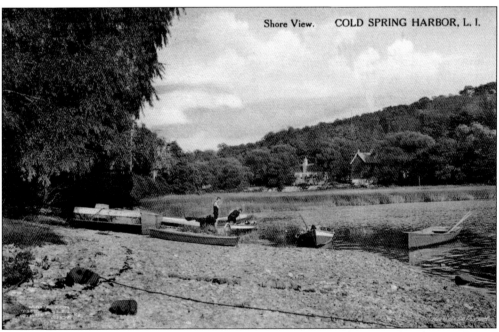

Two men tend to rowboats in the cove near the intersection of Shore Road and Main Street. Visible in the background are the library (left) and the firehouse. In the early 19th century, rocks were placed across the cove to provide a bed for growing oysters. In the 1930s, part of the cove was filled in to provide a village green, now known as Firemen's Park. (Courtesy of the Cold Spring Harbor Whaling Museum.)

Two

FACTORY TOWN

Although Cold Spring Harbor's boast about being the second biggest whaling port on Long Island is well known to local residents, whaling was an active industry for only a short time. That does not mean that Cold Spring Harbor was not an industrial community. In fact, it was the manufacturing of Cold Spring's early mills and cooperage that made the community's foray into whaling possible.

Mills were established in the 17th century. The late-18th-century gristmill continued to operate into the 20th century. The woolen mills opened in response to the increased demand for domestic products in the wake of the War of 1812, which provided the Jones brothers with the wherewithal to outfit whale ships. Cold Spring Harbor also had a factory that produced drums for the military, as well as banjos for musicians and toy drums for children. Cold Spring Harbor in the 19th century was a factory town.

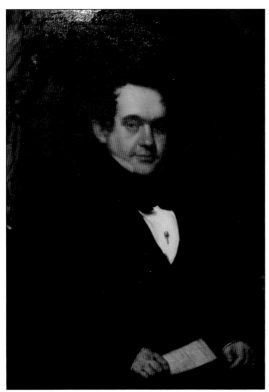

Walter R. Jones (left) and his brother John H. Jones (below) were the driving forces behind much of Cold Spring Harbor's economic activity in the first half of the 19th century. Their father, John Jones, married Hannah Hewlett, whose father had built the gristmill on the east side of the harbor in 1790. Walter and John took over the gristmill and opened a general store adjacent to it. They later established woolen mills to take advantage of the disruption in imports caused by the War of 1812. Walter was engaged in the marine insurance business and was the president of the Atlantic Mutual Insurance Company from its founding in 1842 until his death in 1855. In the portrait, he holds an insurance policy. John initiated the entry into the whaling business. Using the production of the woolen mills and a cooperage he owned on the west side of the harbor, he was able to outfit ships for the months-long voyages to the other side of the world. (Both, courtesy of the Cold Spring Harbor Whaling Museum.)

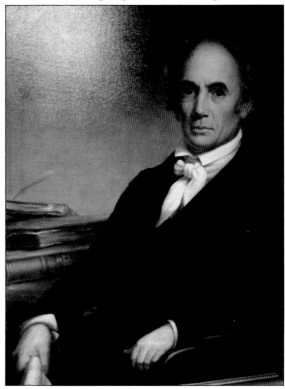

WHALEMEN
WANTED.

Experienced and Green Hands are wanted for the Ship's of the

COLD SPRING WHALING COMPANY

to sail from Cold Spring Harbor, Long Island. Apply immediately to

JOHN H. JONES, *Agent.*

Cold Spring, 6th July, 1839.

Over the course of 26 years, John Jones and his fellow investors sponsored 44 whaling voyages. Each voyage required two to three dozen sailors, preferably with experience. Broadsides such as the one shown above, as well as newspaper advertisements and shipping agents, were used to recruit the crew from far and wide. Only a small portion of the crew were natives of Cold Spring Harbor, and the captain was never a local man. Crew members signed a contract (below) setting forth their pay as a share in the proceeds of the venture. Clothes, shoes, food, and other provisions were provided through the Jones & Hewlett General Store, which became the informal headquarters of the fleet. (Both, courtesy of the Cold Spring Harbor Whaling Museum.)

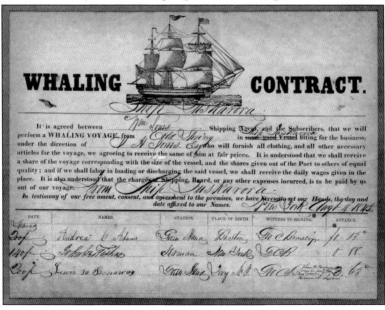

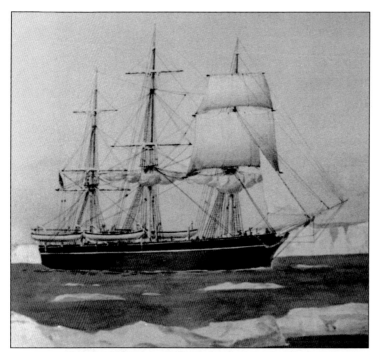

One of Cold Spring Harbor's nine whale ships, the *Edgar*, made only one voyage from Cold Spring Harbor, sailing to the Pacific in 1852. Three years later, in 1855, the ship ran aground in ice and fog in the sea north of Japan. Much of the cargo was salvaged. After the salvage, combined with insurance proceeds and accounting for earlier shipments, the voyage broke even or, perhaps, even made a little money. (Courtesy of the Cold Spring Harbor Whaling Museum.)

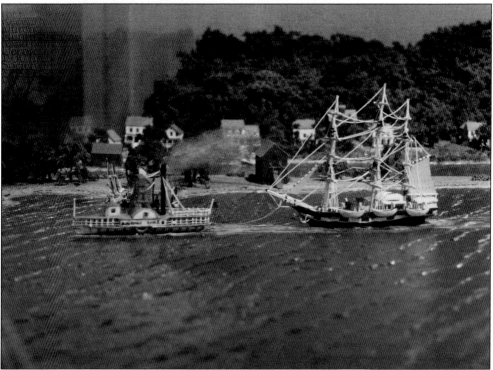

Whaling ships would anchor in the outer harbor and be loaded with the provisions needed for a two-to-three-year voyage, all supplied by the local mills and farms. Ships were then towed out to the Long Island Sound by the steamship *American Eagle*, as shown in this diorama at the Cold Spring Harbor Whaling Museum. (Courtesy of the Cold Spring Harbor Whaling Museum.)

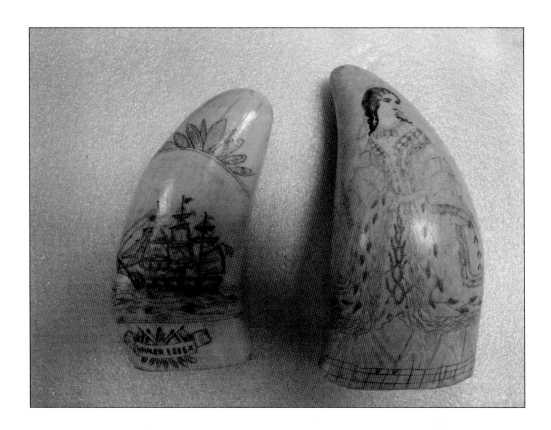

Whaling voyages were often boring and monotonous until a whale was sighted. To help ease the tedium, sailors would etch pictures into whalebones or whale teeth. Two favorite subjects for the whaler's scrimshaw were ships and the women waiting at home, both of which are seen above. Below, a whaler created a scene recounting the hunt, including the whale that fought back, smashing the small whaleboat. (Both, courtesy of the Cold Spring Harbor Whaling Museum.)

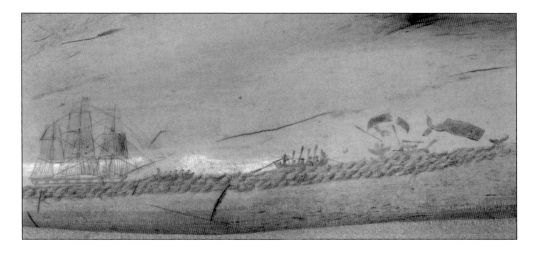

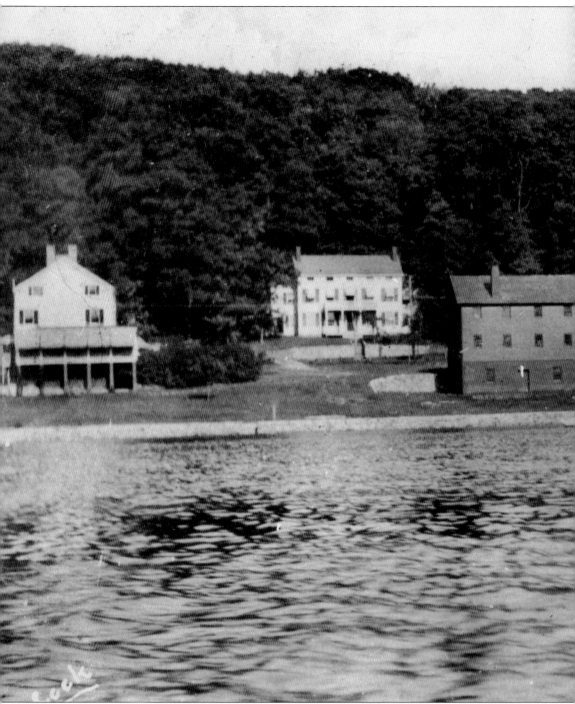

Seen here is the hub of the Jones and Hewlett family industries. On the right is the gristmill, built in 1790. The next building is the Jones & Hewlett General Store, the headquarters for the various Jones family industries. It was here that whalers received their provisions and pay. It is also where the records of the whaling business were kept. Unfortunately, the building and many of the records were destroyed by fire in 1896. The mill was also destroyed by fire in 1921. The

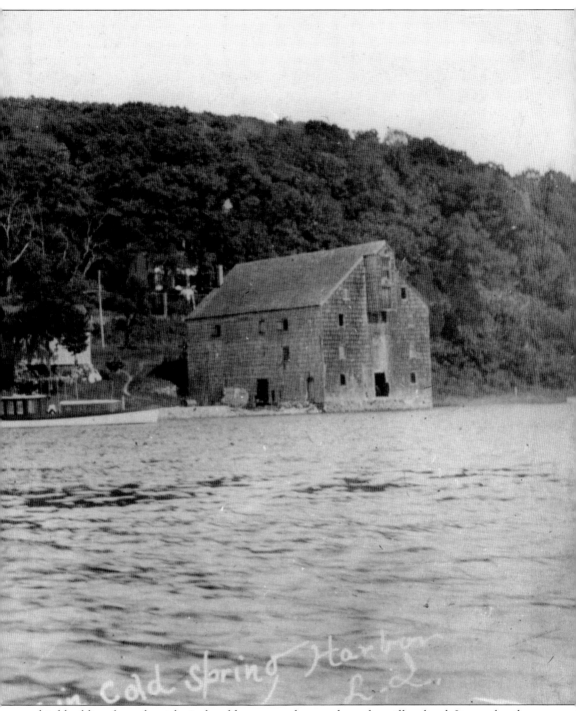

Cold Spring Harbor
L. I.

third building from the right is the old tenement house where the millers lived. It was also the first home of the Cold Spring Harbor Library. On the left is the John H. Jones House. These last two are now owned by the Cold Spring Harbor Laboratories and provide housing for laboratory scientists. (Courtesy of the Huntington Historical Society.)

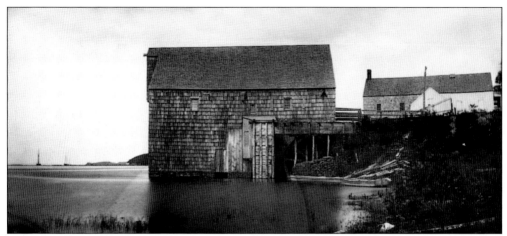

Mills had a much longer history in Cold Spring Harbor than whaling. This gristmill was built in 1790 on the east side of the harbor, about a quarter mile from the head of the harbor. Built by John Hewlett, it came to be part of the various Jones family commercial ventures as a result of John Jones's marriage to Hannah Hewlett in 1779. (Courtesy of the Huntington Historical Society.)

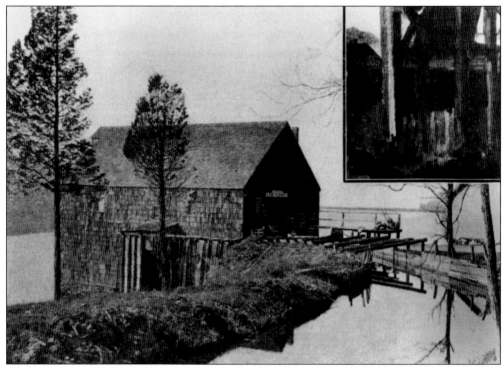

The water to power the mill came through this canal from St. John's Lake. Traces of the canal can still be seen in the wooded area between Harbor Road and the harbor. The mill's location on the harbor was convenient for shipping the finished product to the city market. The mill wheel continued to turn into the 20th century, but it was idle by the time the mill was destroyed by fire in 1921. (Courtesy of the Cold Spring Harbor Whaling Museum.)

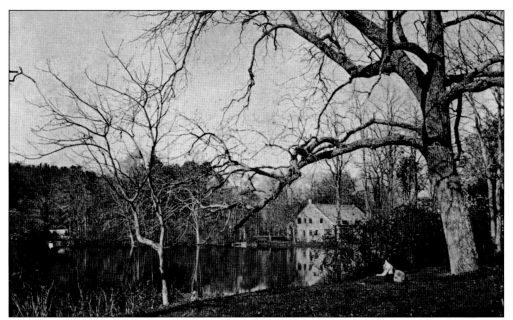

Around 1816, a woolen mill was built on the same site as Cold Spring Harbor's original 17th-century gristmill, on the second (upper) dam. Known as the upper woolen mill, it was where yarn was woven into broadcloth, blankets, and coverlets. The blue and white coverlets, in particular, were highly prized. (Courtesy of the Cold Spring Harbor Whaling Museum.)

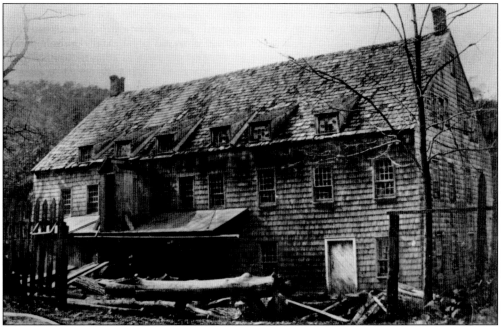

Competition led to the demise of the local woolen industry before the Civil War. In the 1870s, Walter Earle used the old woolen mill to build organs and pianos. One of these organs served the congregation at nearby St. John's Church. He also milled lumber for the local shipyards, as can be seen from this supply of logs waiting to be milled. (Courtesy of the Cold Spring Harbor Whaling Museum.)

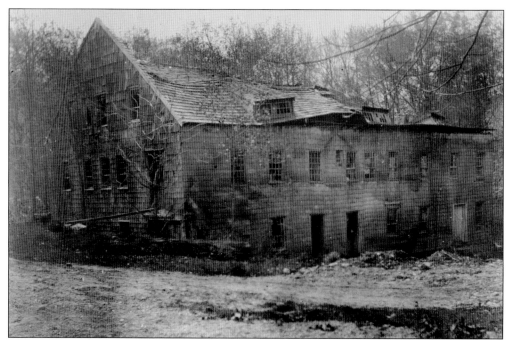

In its heyday, before the Civil War, the mill generated a demand for wool that was met by the sheep raised on farms for miles around. In later years, the mill fell into serious disrepair. It finally collapsed in 1910. (Courtesy of the Huntington Historical Society.)

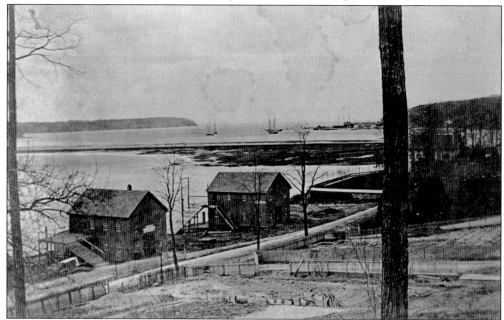

The whaling fleet provided employment opportunities on shore as well as at sea. The woolen mills produced clothing for the whalers. The cooperage provided the barrels to store the whale oil. Local shipyards repaired the ships as needed, and the sail lofts in this image provided and repaired sails. Three sailing ships can be seen at anchor in the distance off of Eagle Dock. (Courtesy of the Huntington Historical Society.)

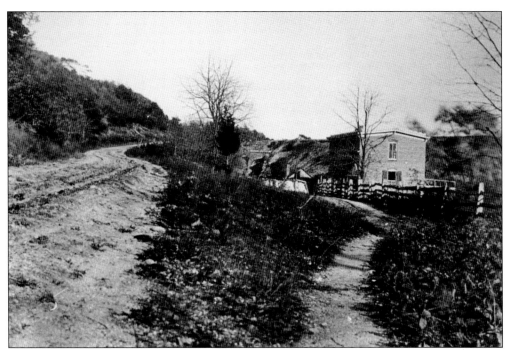

Nestled between the train tracks and West Rogues Path was the Dowden drum factory. Joseph Dowden started tanning animal hides in 1862. This was his third location. Kangaroo hides were tanned for drumheads, and calf hides were used for banjo heads. By the turn of the 20th century, the factory was supplying drums to the Army and the Navy. The tannery closed in 1950. The building is now used as office space for an architectural firm. (Both, courtesy of the Huntington Historical Society.)

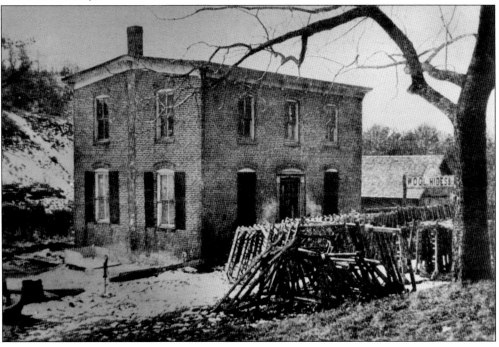

The east side of the harbor was known as Clamtown for the abundance of clams found there. It was also the site of a thriving shipyard and other enterprises, which can be seen through the trees along Shore Road. (Courtesy of the Huntington Historical Society.)

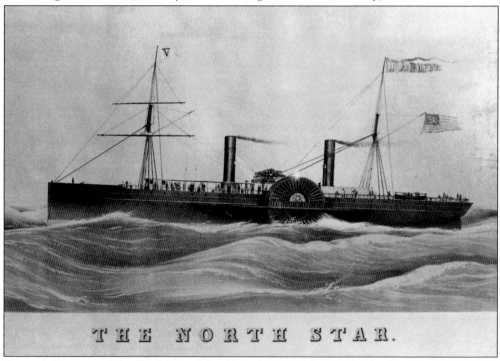

Around the time of the Civil War, John Dole began to dismantle derelict ships to recover their metal hardware on the spit of land on the east side of the harbor, now part of Eagle Dock Community Beach. After he removed all the hardware he could, the ship was burned to recover additional hardware. Timbers from these ships were reportedly used to construct local homes. The most famous ship salvaged at Dole's Beach was Cornelius Vanderbilt's yacht the *North Star*, which was dismantled in 1865. (Courtesy of the Huntington Historical Society.)

Elwood Abrams arrived in Cold Spring Harbor in 1868 and operated a shipyard near Seaman's Dock (now the Seafarer's Club). In 1881, he moved his shipyard to Clamtown on land leased from Charles H. Jones. Abrams eventually added a sawmill. He lived across Shore Road, where he operated an ice cream, soda, candy, and tobacco store, as well as a boardinghouse. In later years, Abrams's shipyard focused more on ship repair and winter storage than on shipbuilding. Other activities in the vicinity of the shipyard included a dance hall, a bowling alley, and a lumberyard. Eagle Dock also served as an entry point for Connecticut and Westchester residents who wished to see the Vanderbilt Cup motorcar races in the early 20th century. During Prohibition, Eagle Dock was reportedly the drop-off point for hundreds of cases of illicit liquor from Canada. (Above, courtesy of the Cold Spring Harbor Library; below, courtesy of the Huntington Historical Society.)

In the 1830s, a steamboat dock was built near the north end of the spit of land known as Middle Beach (now the site of the community beach). Walter R. Jones and John H. Jones acquired this parcel and the adjoining land to the north from the Huntington Board of Trustees in 1837. Within 40 years, the old steamboat dock was in disrepair. In 1885, Dr. Oliver Jones decided to rebuild it, this time with a causeway across the cove to reach Shore Road. Dr. Jones used bricks from his yard in West Neck for fill, which explains the plethora of bricks in the area where the dock had been. The new dock was named Eagle Dock, undoubtedly in honor of the first steamboat to ply Cold Spring Harbor's waters. On the dock, which was really more of a bulkhead pier, was a freight house. The steamboat *Sylvan Dell* made the trip from Eagle Dock to Pier 23 in New York in two hours and 15 minutes, half the time it took the *American Eagle* 40 years earlier. (Above, courtesy of the Huntington Historical Society; below, courtesy of the Cold Spring Harbor Library.)

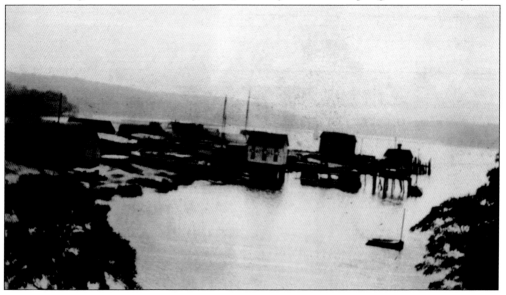

At what is now the entrance to Eagle Dock Community Beach, William Bingham and Benjamin Brush opened a grocery store in 1890. Bingham also dealt in coal, wood, hay, feed, ice, and other items. The store provided provisions for the nearby hotels and large estates. The store closed in 1914. This building was then used as an office for Bingham's construction business. It was finally demolished when the community beach was established in 1948. (Courtesy of the Huntington Historical Society.)

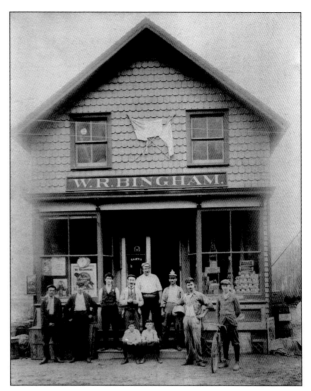

In July 1922, Rosalie Jones, acting as the executor of her mother's estate, sold the shipyard parcel to Elwood Abrams's son Walter, who had taken over the shipyard from his father. Two years later, Walter Abrams sold the land to the Standard Oil Company of New York for $175,000. Abrams moved his shipyard to Halesite. Local legend has it that the oil tanks were the result of the failure of the newly formed Cold Spring Harbor Beach Club to invite members of the Jones family to join. Until they were torn down in 2005, the oil tanks were the last remnant of Clamtown's industrial past. (Courtesy of the Huntington Historical Society.)

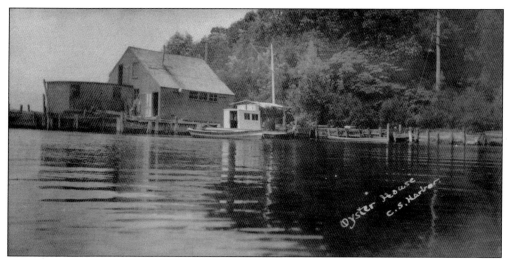

Samuel Walters operated a thriving oyster business from these buildings on the first bend along Shore Road, which was known as Snyder's Point. Walters followed his father, John, into the oyster business. He leased dozens of acres of underwater land from the Huntington Board of Trustees and shipped tons of oysters, both opened and in the shell, to New York City by steamboat and rail. Around 1920, he moved his operations to Seaman's Dock, which was across from what is now the state park's dirt parking lot on Harbor Road. Appropriately enough, his boat was named the *Bivalve*. Walters owned several properties in Cold Spring Harbor. He eventually moved into the old Titus House, located at 56 Shore Road, which he had inherited from his first wife's uncle John E. Titus. His brother Charles was the assistant superintendent of the Cold Spring Harbor Fish Hatchery when it first opened in 1883. (Both, courtesy of the Cold Spring Harbor Whaling Museum.)

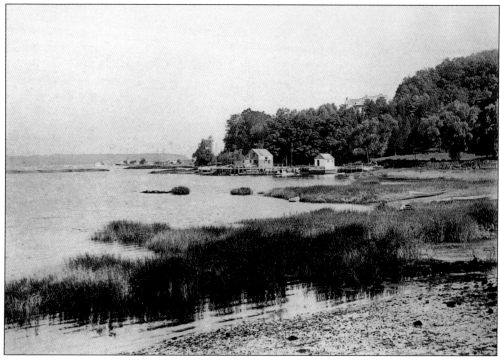

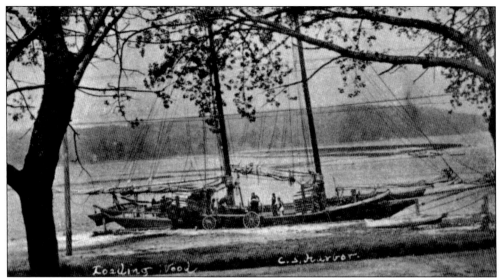

Noah Seaman was a merchant whose house was located on Harbor Road, where the state park's dirt parking lot is now. His store was located across the street, on the harbor. He also had a dock. Here, wood is loaded onto the schooner *Margaret Ann*, one of the last schooners to be used for transporting goods to and from Cold Spring Harbor. Other cargo carried by the *Margaret Ann* in the early years of the 20th century included coal and fertilizer (manure). (Courtesy of the Huntington Historical Society.)

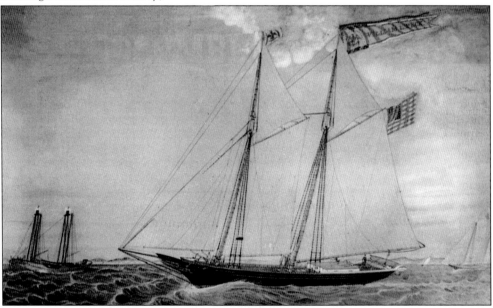

The *William L. Peck* was built in Cold Spring Harbor by John Bennett in 1867. Its captain was Joseph T. Bunce Jr., who lived on Goose Hill Road. The ship carried freight for Peck & Peck, dealers in horse manure. Captain Bunce would load the ship with horse manure from New York City for use as fertilizer on Long Island's farms. In the 1890s, Bunce gave up the ship and became an agent for Peck & Peck, with an office at the store of O.S. Sammis, located on the corner of New York Avenue and Main Street in Huntington village. Captain Bunce died in 1904, and his son Elwood took over as the agent for Peck & Peck. (Courtesy of the Huntington Historical Society.)

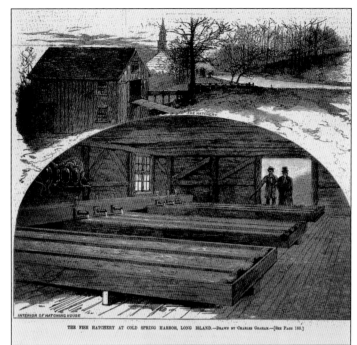

INTERIOR OF HATCHING HOUSE

THE FISH HATCHERY AT COLD SPRING HARBOR, LONG ISLAND.—Drawn by Charles Graham.—[See Page 185.]

The area's freshwater springs came to the attention of Eugene Blackford, a wholesale fish dealer at the Fulton Fish Market and a member of the New York Fisheries Commission. In 1881, the state opened a fish hatchery at the head of the harbor. John D. Jones, a descendant of the proprietors of the various Jones family industries, leased two old woolen factory buildings to the state to start the hatchery. This illustration is from the March 24, 1883, edition of *Harper's Weekly.* (Courtesy of the Huntington Historical Society.)

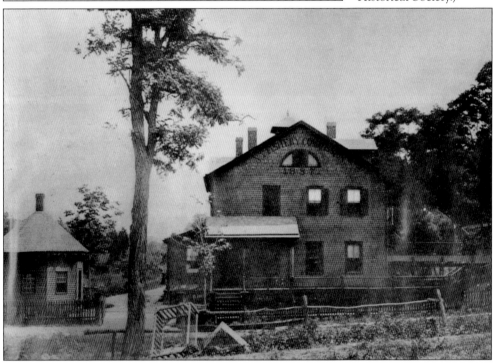

The fish hatchery was an immediate success. Its first superintendent, Frederic Mather, introduced brown trout from Germany. Soon, thousands of pounds of fish were being grown and released into local rivers and lakes. In 1887, the state built this building north of St. John's Church. Assistant superintendent Charles Walters, who succeeded Mather in 1896, and his family lived on the second floor of the house. (Courtesy of the Huntington Historical Society.)

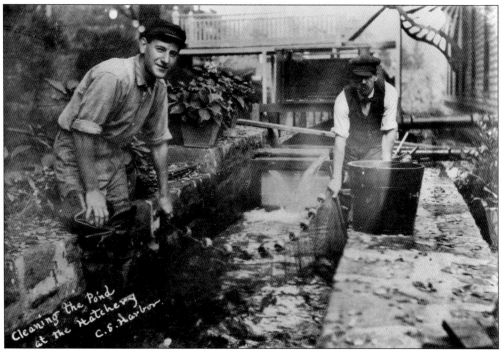

The fish hatchery made use of the natural springs to keep a constant flow of freshwater in the fishponds, which provided the oxygen needed for the fish to thrive and spawn. Stanley Walters (left), the son of assistant superintendent Charles Walters, and another man clean out the pond at the hatchery. Some 20 years later, in 1924, Stanley would take charge of the hatchery and move into the second floor of the hatchery building, where he had grown up. (Courtesy of the Huntington Historical Society.)

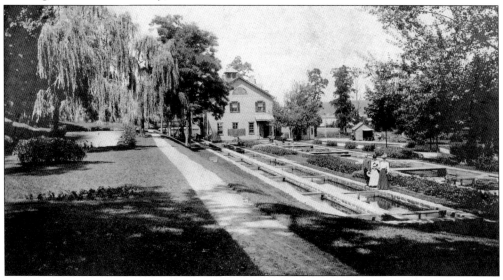

In addition to its intended purpose of raising fish to stock local waters, the hatchery became a tourist destination. For generations, visitors have delighted in seeing the progress of fish as they grow from hatchlings into trout big enough to be caught legally by anglers. (Courtesy of the Huntington Historical Society.)

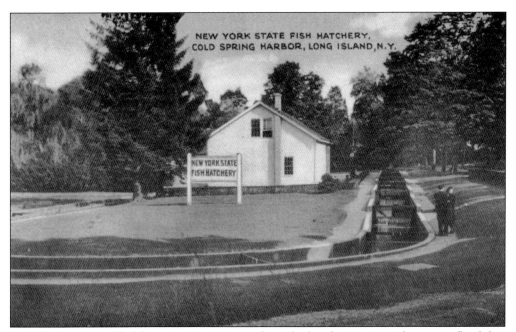

In 1950, the state added four new concrete ponds to the hatchery to provide greater flexibility in managing the flow of water. Each pond could now be emptied and cleaned independently of the others. The hatchery continued to be operated as a state facility until March 31, 1982. Greatly alarmed by the potential loss of this community asset, neighbors formed Friends of the Cold Spring Harbor Fish Hatchery, Inc., which assumed ownership of the hatchery the day after it closed as a state facility. The hatchery now operates as an environmental education center and public aquarium. It also continues to stock local lakes and streams. (Both, courtesy of the Huntington Historical Society.)

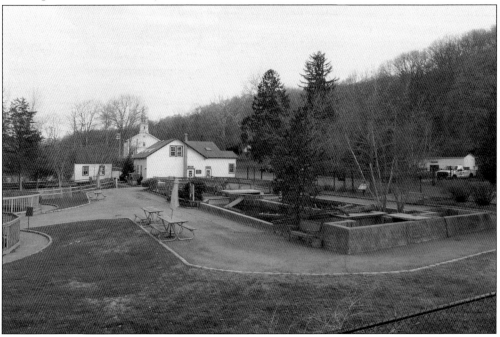

A decade after the fish hatchery was established, Eugene Blackford invited zoology professor Franklin Hooper to Cold Spring Harbor to discuss a seaside zoological station so that students could "study nature, not books." They met for lunch at hatchery director Frederic Mather's new home, pictured here. The house was completed in 1884 and replaced the old John H. Jones House, which had burned down in 1861. The house is named for Charles Davenport, who became director of the laboratory in 1898. (Courtesy of the Huntington Historical Society.)

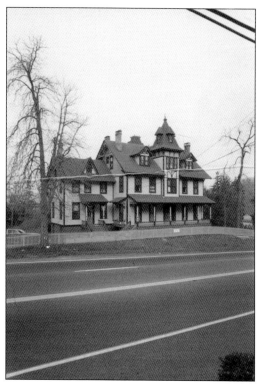

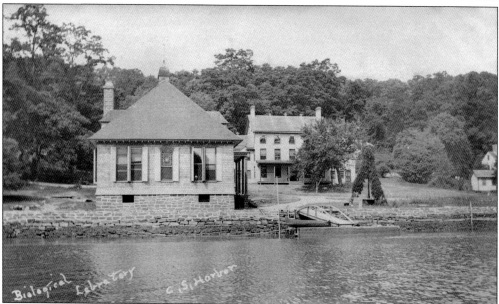

At first, the laboratory used old whaling buildings and the fish hatchery building for classes. In 1893, John D. Jones donated $5,000 for the construction of the lab's first purpose-built facility. Jones Laboratory (left) provided both laboratory and classroom space for the fledgling institution. On the right is the Hooper House. Originally a multiple-family dwelling from the days of the Jones family industries, it served as the lab's first dormitory. Later, it was used as a dining room. (Courtesy of the Cold Spring Harbor Whaling Museum.)

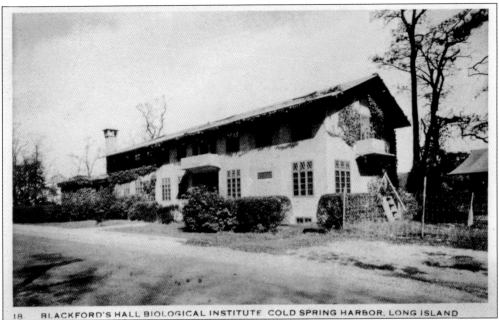

When Eugene Blackford died in 1905, his widow wished to have a memorial dedicated to him at the lab. The board of managers agreed. The lab also needed a proper dormitory and dining hall. The result was Blackford Hall, an early example of a residential concrete building. The concrete was mixed on site. The grain of the wood forms can be seen embedded in the building's concrete walls. (Courtesy of the Cold Spring Harbor Whaling Museum.)

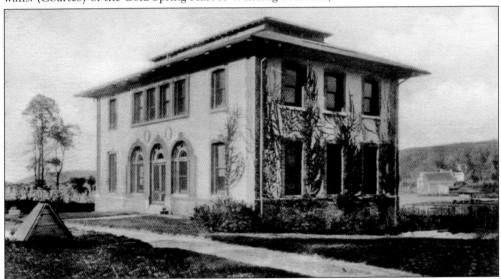

Up until 1904, the lab was only used in the summertime as a teaching lab. Realizing that, in order to survive, it needed to be a year-round research facility, the lab welcomed the Carnegie Institution's Station for Experimental Evolution in 1904. The main building, pictured here, followed in 1905. It served as a laboratory building until 1953, when it was converted into a library. It is now known as the Carnegie Library, but it does not share the origins of the hundreds of public libraries across the country financed by the Carnegie Foundation. (Courtesy of the Cold Spring Harbor Whaling Museum.)

Three

COMMUNITY

As small as it is, Cold Spring Harbor has had a rich history of community involvement, as neighbors have joined together to serve their community and their country. Cold Spring Harbor residents have fought in wars since the American Revolution. They have joined together to fight fires. They established one of the earliest libraries in the state, and they played ball and instruments for the enjoyment of their neighbors.

Cold Spring Harbor was once home to three churches. Only the earliest of these continues to be a place of worship today. The other two still survive, however, and have been adapted to other uses. The community celebrates the past in three wonderful museums. There are also environmental education organizations, hiking trails, and of course, the harbor. The spirit of community service continues to motivate residents to help their neighbors.

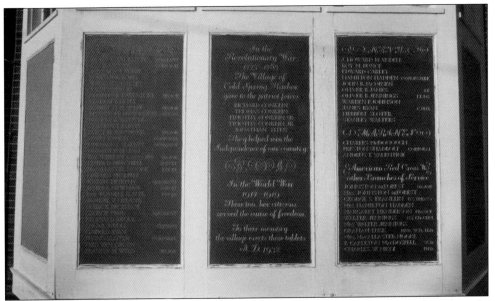

In November 1932, the residents of Cold Spring Harbor dedicated this memorial on the side of the building that then served as the library. The plaque lists the Cold Spring Harbor residents who served in the American Revolution and World War I, in Europe and on the home front. On the same day that this memorial tablet was unveiled, the community dedicated a memorial to the whaling industry. A slate tablet set on a large boulder removed from the harbor lists the whaling voyages from Cold Spring Harbor. That boulder now stands in front of the Cold Spring Harbor Whaling Museum. (Courtesy of the Huntington Historical Society.)

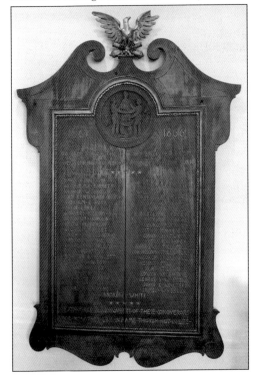

During the planning for Cold Spring Harbor's new library building, situated on the corner of Shore Road and Main Street, the library's directors decided to include a Civil War memorial. The wooden tablet was installed in 1915. The tablet lists the names of 43 men from the two Cold Spring Harbor school districts (East Side and West Side) who fought in the Civil War. (Courtesy of the Huntington Historical Society.)

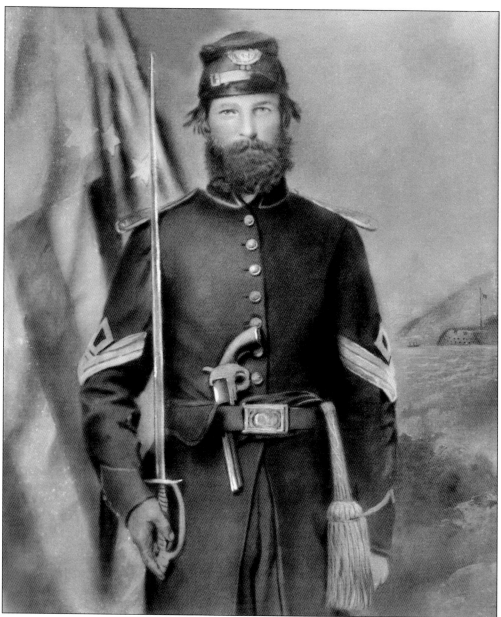

Jacob C. Walters was reportedly involved in the San Francisco Gold Rush of 1849, but he returned to Cold Spring Harbor without a gold fortune. In 1856, he married the recently widowed Eliza Jane Chesire. In October 1861, he was 35 and the father of three girls when he enlisted in the 102nd Volunteer Regiment in Cold Spring Harbor. Less than a year later, he was killed at the Battle of Cedar Mountain in Virginia, becoming the first man from the town of Huntington to die in the Civil War. After the war, a Grand Army of the Republic post was formed in Cold Spring Harbor. The post, part of the fraternal organization for Civil War veterans, was named in his honor. He is also commemorated on the memorial tablets in both the Cold Spring Harbor Library and the Soldiers and Sailors Memorial Building in Huntington, the latter of which was originally constructed as the first library in the town of Huntington. (Courtesy of the Huntington Historical Society.)

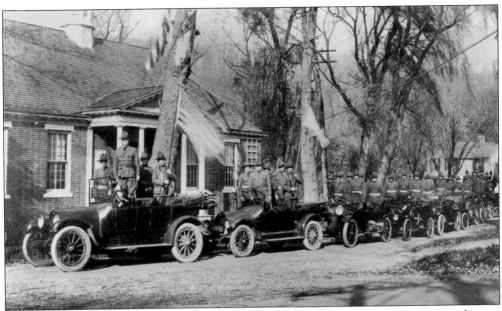

A few days before the United States entered World War I in April 1917, Charles Davenport, director of the Bio Labs, invited the men of Cold Spring Harbor to a meeting at the library to discuss ways to protect the community against a possible uprising by local German sympathizers. The result was the formation of a Home Defense Guard. The Guard, made up of local volunteers, would drill regularly and stand ready to answer any emergency call for police duty. With the outbreak of war, the State Guard was mustered into federal service. Local Home Defense groups were invited to join the State Guard to replenish its ranks. The Huntington Home Defense Guard did so, while the Cold Spring Harbor unit remained as a Home Defense Guard. Residents of the western half of the town of Huntington were invited to join either group, regardless of which hamlet they lived in. In July 1917, the unit became part of the State Home Defense Reserve as the 97th Company. (Both, courtesy of the Huntington Historical Society.)

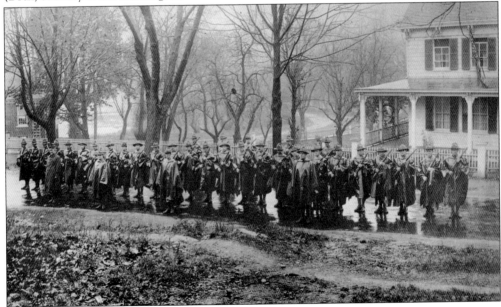

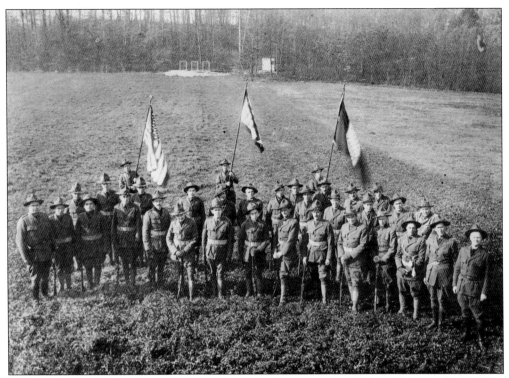

Robert W. DeForest and Helen Titus made their fields on Goose Hill Road (part of which is now the site of Goosehill Primary School) available to the Home Defense Guard for weekly drills. A target range was built on the DeForest property, and lights were installed at the Titus field. Under the leadership of H.H. Laughlin, who had served as a lieutenant in the Kansas National Guard, the Cold Spring Harbor Guard drilled every week until January 3, 1919, two months after the Armistice was signed. In all, 96 men received training as part of the Guard, and 39 of them went into federal service. (Both, courtesy of the Huntington Historical Society.)

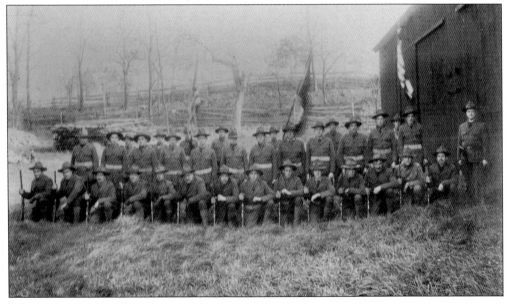

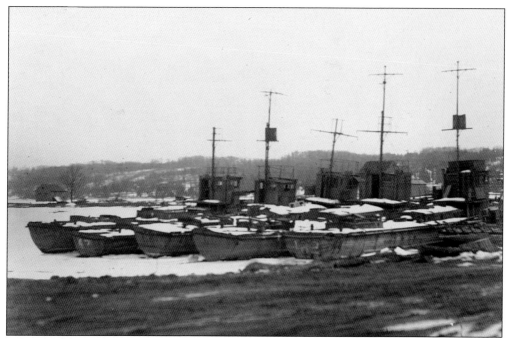

After World War I, these submarine chasers found their way to Cold Spring Harbor. Little information is available about the ships. The hull markings on one (see page 27) identify the ship as SC 43. According to the Subchaser Archives, SC 43 was a wooden-hulled, 110-foot-long ship built at the Brooklyn Navy Yard and commissioned on May 16, 1918. The ship was reportedly sold to Joseph Hitner of Philadelphia in June 1921. It is unknown how it came to be at Cold Spring Harbor. In any event, two of the subchasers were left to rot in the cove at Eagle Dock Beach, as can be seen below. A few of the ship's timbers can still be seen at low tide. (Both, courtesy of the Huntington Historical Society.)

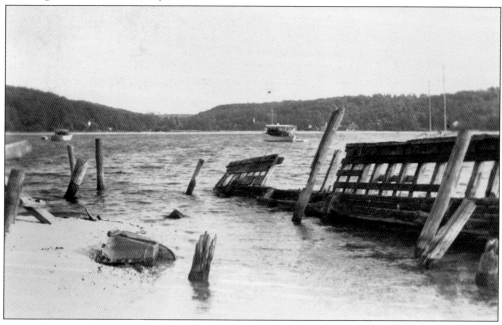

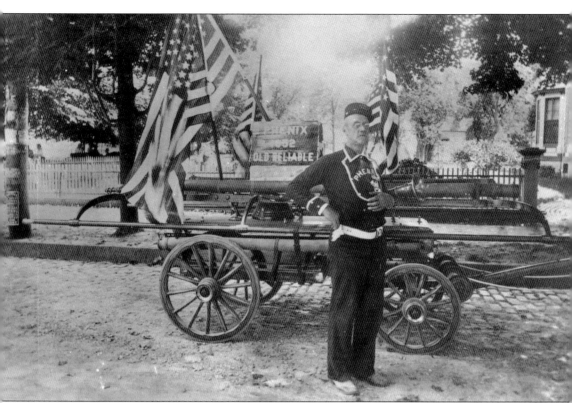

At the height of the village's whaling activity, a group of residents formed a fire protection company. In 1852, the Eagle Engine Company raised $500 and purchased the hand pumper pictured here with John Titus. The company was a purely volunteer effort that received no tax funds. The pumper was kept near the gristmill and the Jones & Hewlett General Store, on the east side of the inner harbor. The fire company does not appear to have met regularly, and by the 1890s, the pumper was in serious disrepair. A fire at the former Jones & Hewlett General Store, then operated by Frank O'Neil, on Easter morning in 1896 exposed the precarious state to which firefighting in Cold Spring Harbor had been allowed to fall. The pumper was useless, and the building was a total loss, with many whaling artifacts, such as captain's logbooks, destroyed. The next day, a group met to call for the formation of a taxpayer-supported fire district. (Courtesy of the Huntington Historical Society.)

NOTICE!

Fire District Election.

Whereas by an act of the Board of Supervisors, of the County of Suffolk and State of New York, passed on the 29th day of September, 1896 and re-enacted Nov. 12, 1896, establishing a FIRE DISTRICT AT COLD SPRING HARBOR, TOWN OF HUNTINGTON, SUFFOLK CO., N. Y. the territory comprising said fire district is described as follows :

All that part of the village of Cold Spring Harbor and vicinity as lies within the County of Suffolk, and one mile in every direction within from the building known as the Teal Building, situated in the said village and to be used for fire purposes of the fire district.

And Whereas such territory was set apart and constituted a fire district, pursuant to sec. 37 of the county law, a Special Election for the purpose of electing FIRE COMMISSIONERS and TREASURER for said district being necessary, Now Therefore notice is hereby given that a special election for said district to be held at the TEAL BUILDING, in the VILLAGE OF COLD SPRING, HARBOR on the

27th day of November, 1896,

for the purposes above stated. Polls to be opened between the hours of 5 and 8 o'clock, P. M.

Dated, Nov. 17, 1896.

PHILIP PEARSALL, TOWN CLERK.

A series of meetings held in April 1896 following the Easter morning fire at O'Neil's store resulted in the formation of two fire protection companies. The first was the Hook & Ladder Company, which raised funds by subscription to purchase a hook-and-ladder truck from the Gleason & Bailey Manufacturing Company of Seneca Falls, New York. The second company, formed in November 1896, was the Phoenix Engine Company No. 1, which utilized the old hand pumper. It was common practice to form different companies to operate the different types of equipment. The hook-and-ladder truck provided ladders and hooks, or pikes, used to pull apart a burning building. Engine companies operated the pumper trucks. The more important order of business was the formation of a fire district under the terms of a new state law. The vote was held at the former harness shop of George F. Teal on November 27, 1896. The vote to create a fire district passed. (Courtesy of the Huntington Historical Society.)

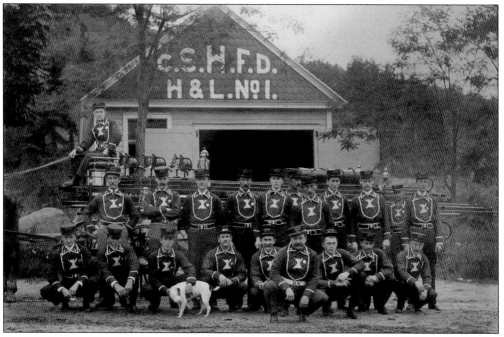

The first home of the newly formed fire district was the former harness shop of George Teal. The boundaries of the district were set at one mile from the Teal Building, which stood where the current firehouse now stands. (Courtesy of Jennifer Hayes.)

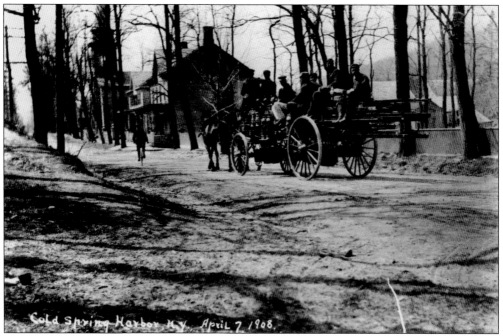

The Phoenix Engine Company No. 1 repaired the old 1852 hand pumper and parked it at Thespian Hall, which was located on the east side of Harbor Road, north of Terrace Place. Here, in 1908, the horse-drawn hook-and-ladder truck and firefighters are returning from a fire, heading west down Main Street near Spring Street. (Courtesy of the Huntington Historical Society.)

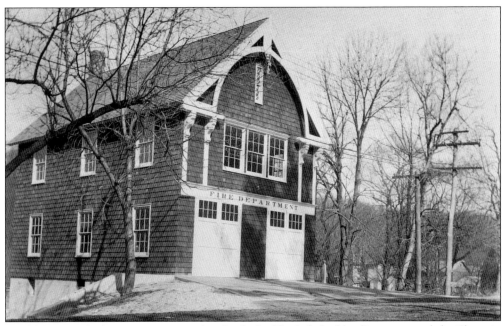

In 1906, a new firehouse to accommodate both the Hook & Ladder Company and the Phoenix Engine Company was built on the north side of Harbor Road, across from the current firehouse. The fire district issued bonds totaling $3,000, at five percent interest, to finance the construction of the new firehouse. The new building (above) was dedicated on July 21, 1906. The Kings Park Brass Band (below) led a parade that marched through the village from the firehouse to the Jones house, situated at the corner of Harbor and Lawrence Hill Roads; then back past the firehouse; up Shore Road to the Bingham Store, at the entrance to Eagle Dock; then back to Main Street to the East Side School, on Main Street across from Goose Hill Road; and finally, back to the firehouse. A total of 600 guests enjoyed dinner in the firehouse. The two companies were merged to form the Cold Spring Harbor Fire Company No. 1 in 1923. (Above, courtesy of the Huntington Historical Society; below, courtesy of the Cold Spring Harbor Library.)

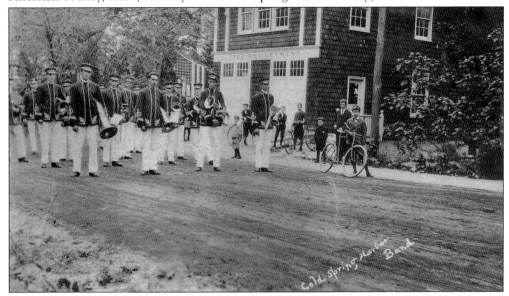

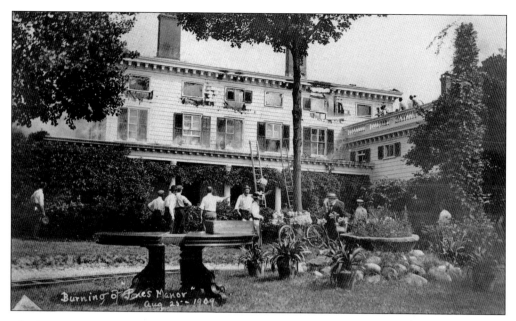

Burning of Jones Manor
Aug 23 - 1909

The fire department counts some two-dozen notable fires in its history. Two of the earliest were the burning of the Jones Manor (above), in Laurel Hollow, in 1909, and the burning of the Requa barn (below), on Main Street, in 1911. The Jones Manor was a 40-room Georgian mansion constructed by Walter R. Jones in 1850. The fire started when a kerosene lantern in the cupola was left lit. The 1852 hand pumper was towed to the fire, but to no avail. The building was a total ruin. Perhaps this fire inspired Walter Jennings to donate a steam pumper the following year. The Requa barn fire started in the hayloft on the second floor of the barn in the middle of the day. The horses and wagons on the first floor were saved, but many valuable items on the second floor were lost, as was the building itself. (Both, courtesy of the Huntington Historical Society.)

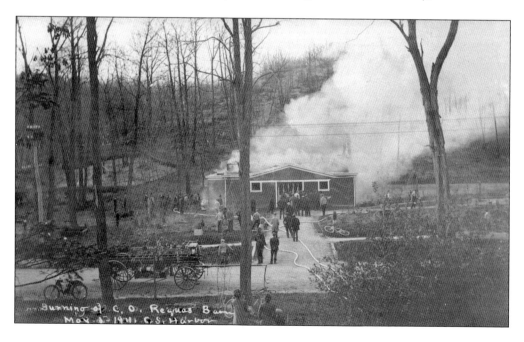

Burning of C. O. Requa Barn
May 6 1911 C. S. Harbor

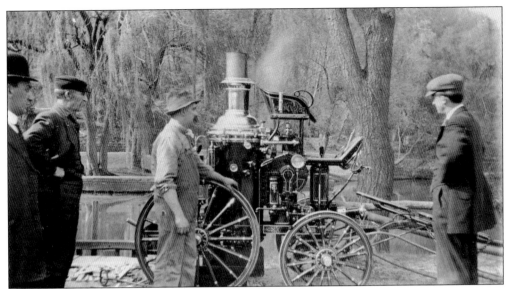

In 1910, Walter Jennings donated a steam-powered pumper to the fire department. The firemen held a "jollification" to celebrate the new steamer. The old hand pumper is now on display in the Cold Spring Harbor Firehouse Museum. The 1910 steamer is at the Museum of Firefighting in Hudson, New York. (Courtesy of the Huntington Historical Society.)

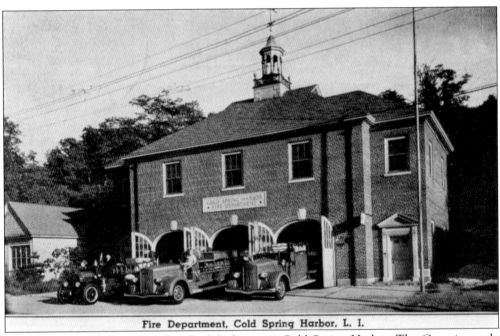

Fire Department, Cold Spring Harbor, L. I.

In 1930, the fire district built the third firehouse in Cold Spring Harbor. The Georgian-style three-bay firehouse was built across the street from the 1906 firehouse. An addition to the 1930 firehouse was built in 1970 to accommodate larger trucks, and the front facade of the 1930 building was reconfigured. (Courtesy of the Cold Spring Harbor Whaling Museum.)

To help finance the cost of the 1930 firehouse, the 1906 firehouse was auctioned off. The Bio Labs had the high bid at $50. The firehouse was lifted off its foundation, placed on a barge (above), and floated across the harbor to the grounds of the Bio Labs (below), where it is still used today as a residence for scientists. (Both, courtesy of the Cold Spring Harbor Whaling Museum and the Huntington Historical Society.)

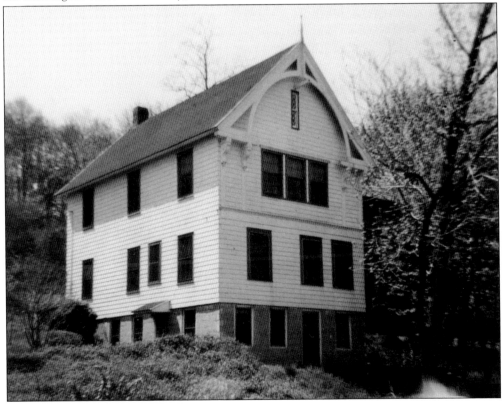

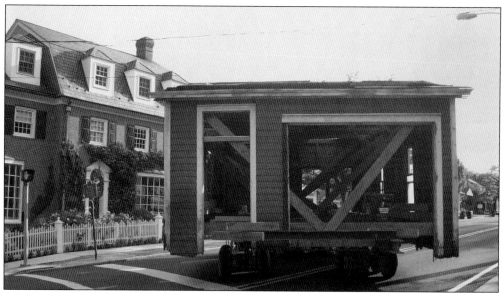

After serving as the home of a shop called Firehouse Antiques, the 1896 firehouse was eventually moved behind the current firehouse and used for storage. In 2008, Tom Hogan, a member of the fire department, arranged to move the old firehouse to property he owned a few doors east on Main Street. Early on a Sunday morning, the building (above) was towed to its new location (below), where it was restored and enlarged. The building, which had served as a harness shop, a firehouse, and an antiques store, was now a museum. Inside is Cold Spring Harbor's original hand pumper, as well as other firefighting equipment. Outside is the cupola (below, left) from the 1930 firehouse. (Both, courtesy of the Huntington Historical Society.)

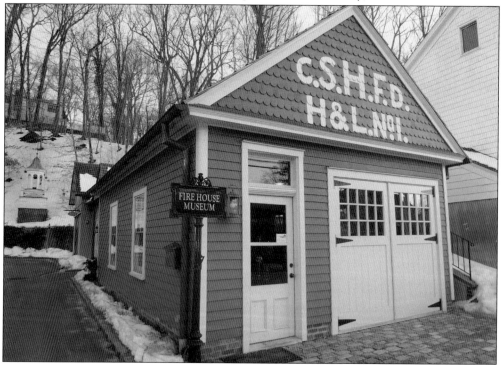

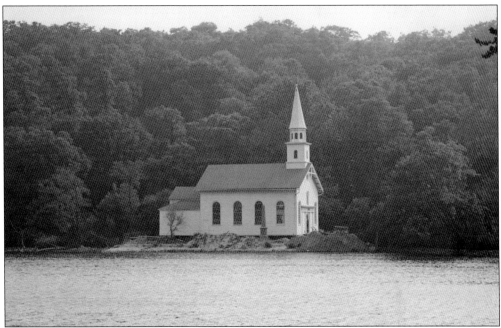

Organized religion came to Cold Spring Harbor in 1831 with the establishment of St. John's Episcopal Church. The first services were held in the schoolhouse built in 1790 at the head of the harbor. Soon, money was raised, and land was secured from John H. Jones for the construction of a church. The new church building was consecrated in April 1837. (Courtesy of the Huntington Historical Society.)

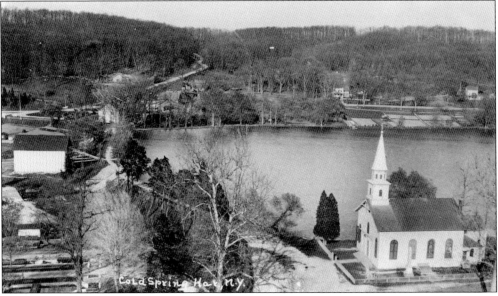

Originally, the road between Huntington and Oyster Bay ran across the meadows at the head of the harbor. By the 19th century, the route ran over the lower dam, which created St. John's Lake. The St. John's rectory house, seen in the distance on the right, was bequeathed to the church by Florence L. and S. Elizabeth Jones. The church also gained ownership of the lake. (Courtesy of the Huntington Historical Society.)

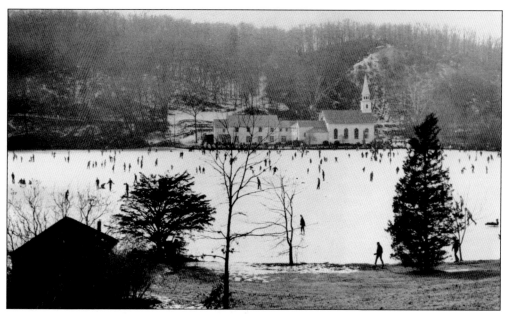

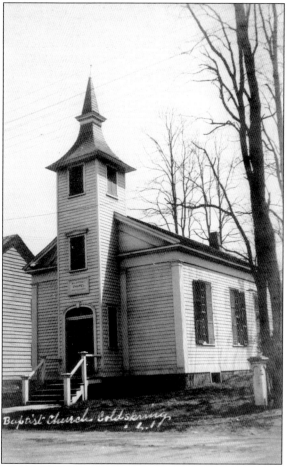

St. John's has been moved slightly and enlarged over the years, while the pond became a favorite ice-skating venue. In 1950, the church building was moved north and 50 feet east onto landfill to allow the parish house to be enlarged. Additional land was purchased to the south, and another addition was constructed in 1962. A major renovation and modernization of utilities was undertaken in 2012. (Courtesy of the Huntington Historical Society.)

The Baptist Chapel was built in 1845 on land purchased from Daniel Rogers. New congregants were baptized in the harbor—sometimes in the middle of winter. The Methodist and Baptist congregations carried on a friendly rivalry for over 100 years until they merged in 1960. The Baptist Chapel became the parsonage for the new Community Methodist Church. The chapel is now a private residence on the corner of Main and Poplar Streets. (Courtesy of the Huntington Historical Society.)

The Methodist church, located on Main Street, was dedicated on October 23, 1842. The church has undergone several changes over the years, most notably to its steeple. The original Gothic Revival building was altered in 1874 when an anteroom and an elaborate Gothic Revival steeple (right) were added. In 1961, the building was remodeled as a Colonial Revival building and the steeple was replaced with a simple bell tower (below). The church building was acquired by the Society for the Preservation of Long Island Antiquities in 1996 and is now used as the group's administrative offices. The main floor serves as a gallery and lecture hall. (Both, courtesy of the Huntington Historical Society.)

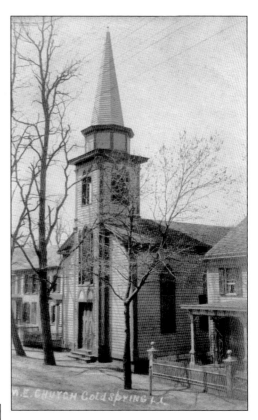

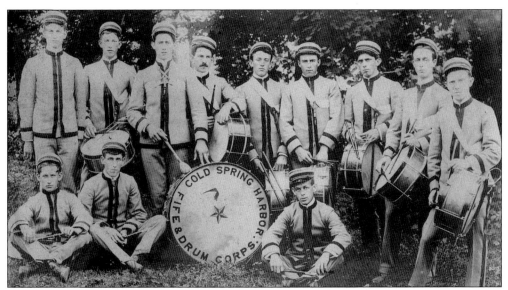

In the early 20th century, the Cold Spring Harbor Fife & Drum Corps would accompany members of the J.C. Walters Post of the Grand Army of the Republic at Memorial Day ceremonies, leading the post to decorate the graves of veterans in the Old Burying Ground and at Huntington Rural Cemetery. In September 1903, the Corps participated in a different type of ceremony when they serenaded Rev. W.W. Robinson of the Methodist congregation and his new bride at a surprise reception following their wedding. Seen below from left to right are (first row) Wilson Gildersleeve, William McKowen, John Terwilliger, Frank Nichols, and Bonnie Allen; (second row) Oscar Gardiner, Frank Raynor, Rubin Gildersleeve, Frank Doty, Floyd Rogers, James Newman, Stephen Pedrick, Morton Gildersleeve, Milton Gardiner, Stanley Walters, and Silas B. Carey. (Above, courtesy of the Cold Spring Harbor Library; below, courtesy of Jennifer Hayes.)

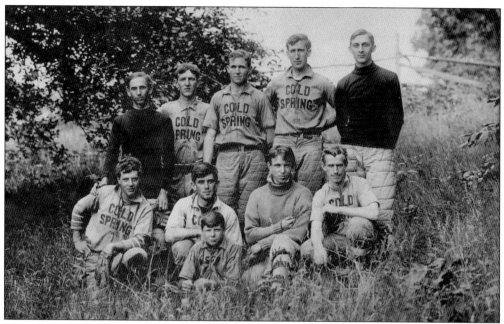

From the late 1800s into the early 20th century, Cold Spring Harbor fielded a baseball team to compete against teams from across Long Island. Home games were played at the DeForest's field on Goose Hill Road, which is now the site of Goosehill Primary School. The team benefited from the pitching of Rev. Edgar S. Jackson of the Cold Spring Harbor Methodist Episcopal Church. Reverend Jackson had played ball at Northwestern University. He was recruited by professional teams but opted for the ministry instead. One of his first assignments was to Cold Spring Harbor, where he put his pitching skills to good use. (Both, courtesy of the Huntington Historical Society.)

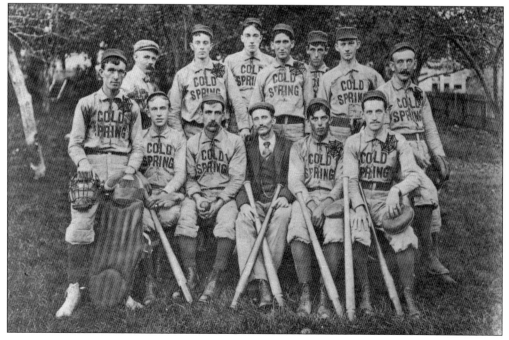

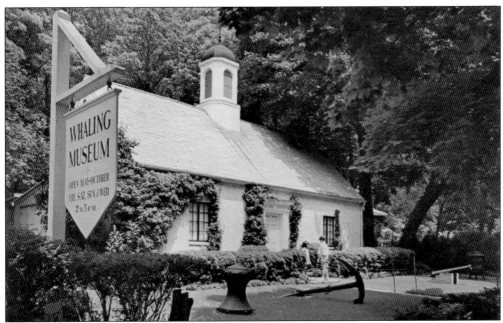

A century after whaling ships first left Cold Spring Harbor, village residents created a museum (above) to preserve that aspect of the community's history. Robert Cushman Murphy, the curator of birds at the American Museum of Natural History, asked Charles Davenport, who was recently retired as the director of the Bio Labs, if Cold Spring Harbor would build a museum for a fully equipped whaleboat from the brig *Daisy*, which had been built in Setauket and registered in New Bedford. After some initial resistance from descendants of the whaling families, who questioned the boat's authenticity and its lack of a connection to Cold Spring Harbor, the museum was built in 1942. Although the *Daisy* did not sail from Cold Spring Harbor, the whaleboat (below) is New York State's only fully equipped 19th-century whaleboat with original gear. The museum also boasts one of the most notable scrimshaw collections in the Northeast. (Both, courtesy of the Huntington Historical Society.)

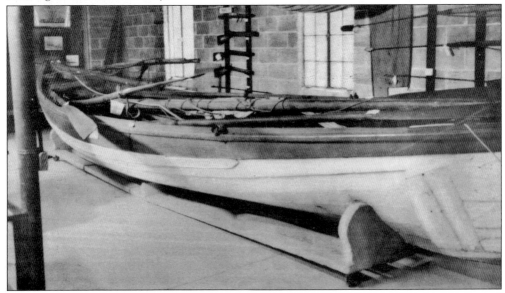

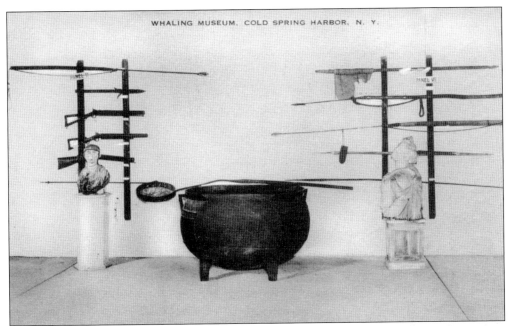

The early view of the Cold Spring Harbor Whaling Museum above shows some of the artifacts from Cold Spring Harbor's whaling days, including a trying pot, which was used to boil whale blubber into oil, and harpoons. A centerpiece of the museum is the diorama below, created in the 1970s by Peter Bongo to painstakingly depict Cold Spring Harbor in the 1850s. This view of the gristmill and general store closely matches the view on pages 20 and 21. (Both, courtesy of the Cold Spring Harbor Whaling Museum.)

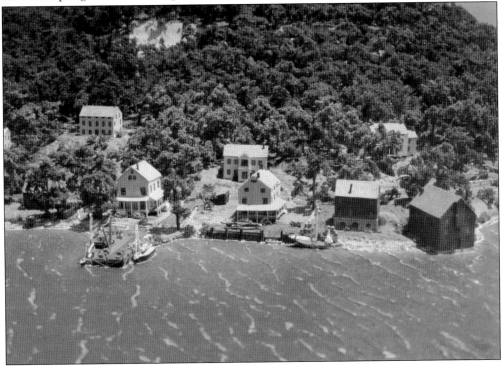

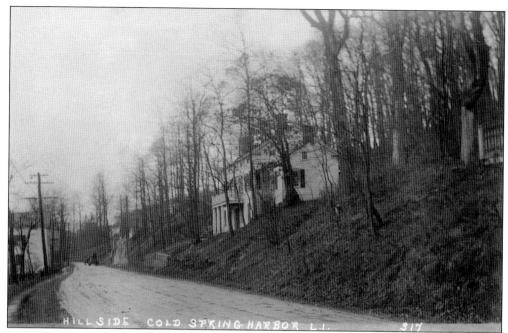

In 1886, residents formed a library for the small community. Its first home was in this building, which had been the tenement house for employees of the Jones family industries. It was conveniently located across the street from the gristmill and the Jones & Hewlett General Store. (Courtesy of the Huntington Historical Society.)

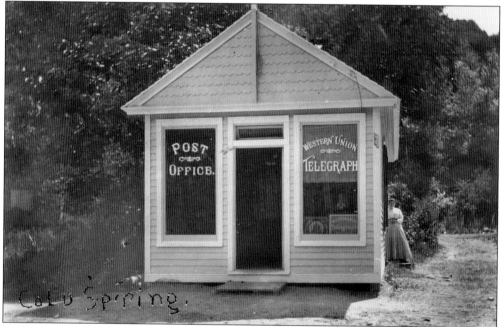

By the turn of the 20th century, the small collection of books was held in the post office and Western Union telegraph office, the small building seen here, located across from the intersection of Main Street and Shore Road. The building was later used as a candy store and barbershop. It is still a barbershop, but no candy is sold there. (Courtesy of the Huntington Historical Society.)

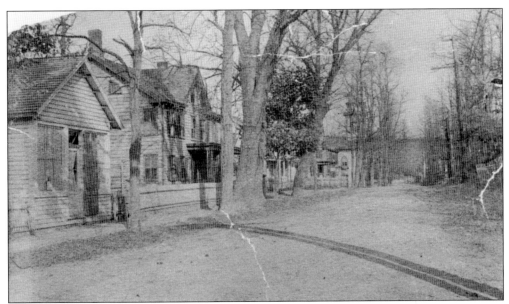

The small building on the far left was owned by the Lockwoods, whose house was next door. It was the home of the Cold Spring Harbor Library until the brick building on the corner of Shore Road was built in 1913. (Courtesy of the Huntington Historical Society.)

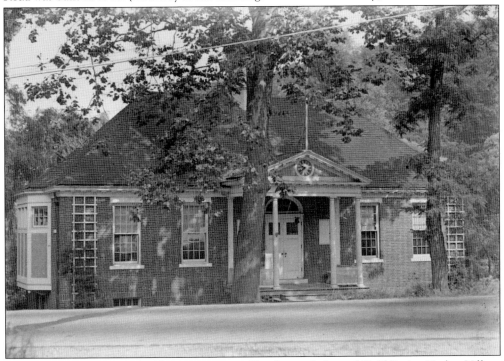

In 1900, the operation of the library was assumed by the newly formed Cold Spring Harbor Village Improvement Society, which had been created to improve conditions in the village, especially the roads and sanitary conditions. The Village Improvement Society initiated a fundraising campaign that resulted in the construction of the building pictured here in 1913. (Courtesy of the Huntington Historical Society.)

In 1986, the library sold its cramped building to the Society for the Preservation of Long Island Antiquities and relocated once again to the closed East Side School on Goose Hill Road. The library stayed in the rented space on Goose Hill Road for almost 30 years, until the school district needed the space for its growing enrollment. Once again, the community raised the funds for a new library building. After securing land once slated for a parkway to Caumsett State Historic Park, the library opened on a hillside overlooking the harbor, not far from its original home, in 2006. (Courtesy of Kenneth Pritchard.)

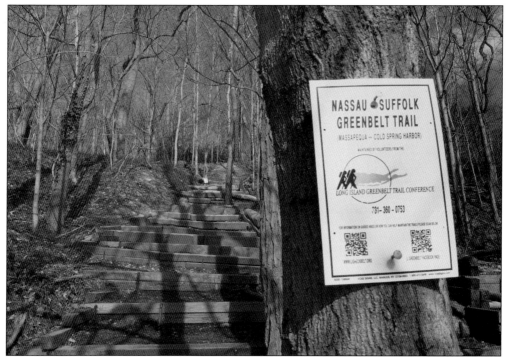

When the library approached the state about using a section of the land that had been slated for a parkway, the state decided to use the opportunity to create the 40-acre Cold Spring Harbor State Park. The hilly terrain of the park serves as the northern terminus of the Nassau-Suffolk Greenbelt Trail, which extends 16 miles to Massapequa, situated on the South Shore. (Courtesy of the author.)

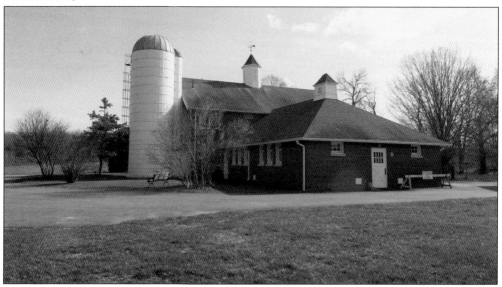

Not all former estates were developed for housing. Jane Nichols, a longtime resident and owner of Uplands Farm (see page 86), donated three parcels of her estate to the Nature Conservancy in 1962. When she died in 1981, additional parcels were bequeathed to the Conservancy. The main house of the estate remains in private ownership. (Courtesy of the author.)

Four

HOME SWEET HOME

Every community is identified at least partially by its homes. Cold Spring Harbor homes date from as far back as the 17th century. They range from simple farmhouses to sea captains' houses to summer bungalows to some of the most impressive mansions of the Gilded Age. Fortunately, many of these historic homes still stand today.

In 1976, the Huntington Town Board created the Cold Spring Harbor Historic District to protect these old homes. Encompassing houses along Goose Hill Road, Main Street, Harbor Road, and Shore Road, the district includes over 200 houses. Within that locally designated historic district are four districts listed in the National Register of Historic Places.

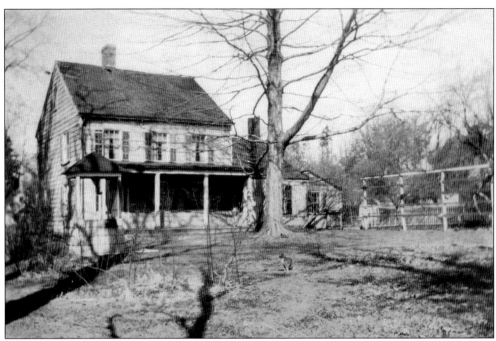

Capt. Joseph Titus Bunce raised four sons who also became ship captains in the house above, at 40 Goose Hill Road. The Bunce family first came to Huntington in 1672. The small saltbox wing is thought to date to the 1770s, when the building may have been in the Titus family. The larger wing was probably added by Captain Bunce when he began to raise his family in the early 19th century. One of his sons, Joseph T. Bunce Jr., born in 1838, may have built the house at 38 Goose Hill Road (below, right) when he married Alma Gardiner in 1868. (Both, courtesy of the Huntington Historical Society.)

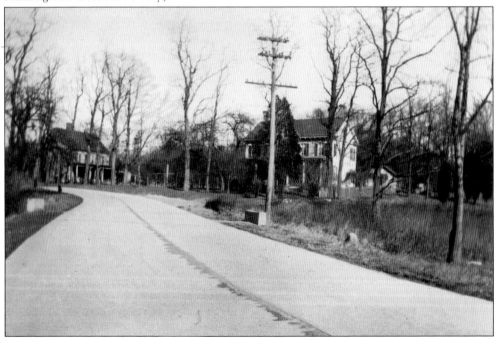

Capt. Joseph T. Bunce Jr. is seen here in front of his home on Goose Hill Road. Joseph Jr. was engaged in the coastal trade as captain of the locally built schooner the *William L. Peck*. This house remained in the Bunce family until 1997. It was restored in 2009. (Courtesy of the Cold Spring Harbor Whaling Museum.)

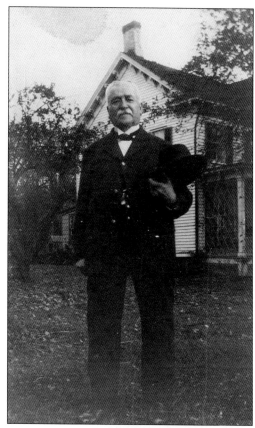

The Titus-Bunce House, seen here, was built around 1820 for a member of the Titus family. The simple cornice and box gutters were updated in the 1850s with the addition of Italianate brackets and details. (Courtesy of the Huntington Historical Society.)

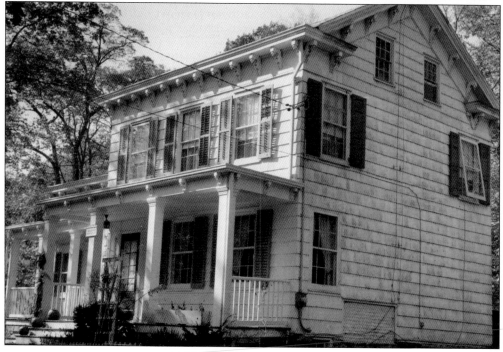

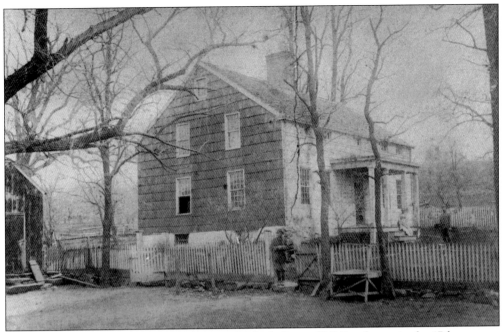

The Titus family settled in the valley through which Goose Hill Road runs in the 17th century. The house at 26 Goose Hill Road (seen above and below), the oldest surviving house in Cold Spring Harbor, was built before 1700 and remained in the Titus family until 1963. In the late 19th century, Andrus Titus kept the large farm and orchard in excellent condition and also raised coach horses here. His daughter married Israel Whitson Valentine, who was a justice of the peace for the Town of Huntington. They inherited the house when Andrus died in 1897. Their son Andrus Titus Valentine and his wife, Harriet, along with Andrus's sister Estelle Valentine Newman, were three of the foremost scholars of Cold Spring Harbor history, active in both the Huntington Historical Society and the Cold Spring Harbor Whaling Museum. (Both, courtesy of the Huntington Historical Society.)

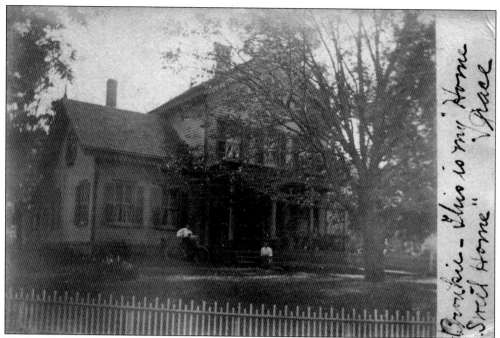

The house on the corner of Main Street and Turkey Lane was home to a succession of sea captains. The first was Capt. Charles I. Bunce, followed by Capt. Allen Gurney and then by Capt. Charles H. Newman. Captain Gurney settled here by 1889. He was involved with the coastal trade until his retirement in 1913. This postcard was written on by Captain Gurney's 14-year-old daughter Grace, who wrote, "This is my home sweet home." (Courtesy of the Huntington Historical Society.)

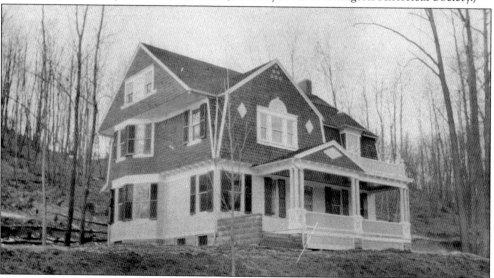

This house was built in 1907 by Cornelius Requa. As a boy growing up on Goose Hill Road, Requa grew tired of farming and decided to start a coffee business. He ordered a bag of coffee beans, ground them by hand, packaged the coffee in small brown bags, and sold them door-to-door. The business was a success, and he was soon joined by his younger brother Aitkin. In 1907, the brothers moved the operation to property behind the house at 196 Main Street. Cornelius, who never married, died in 1939. (Courtesy of the Huntington Historical Society.)

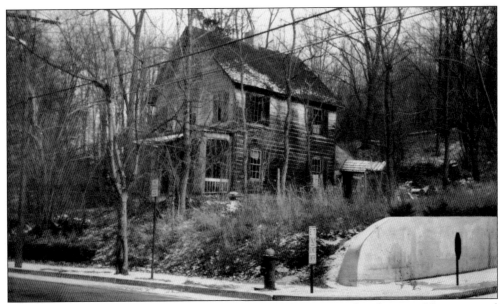

This house was on the site of the current post office building, situated to the east of the municipal parking lot. The last owner was Jennie Hawxhurst, a widow, who lived here with her blind son George. When the Industrial Home for the Blind opened in 1952 at Burrwood (see page 84), George went to live there. When Jennie died in 1953, she bequeathed the house to the Home for the Blind. The post office was built in 1962. (Courtesy of the Cold Spring Harbor Whaling Museum.)

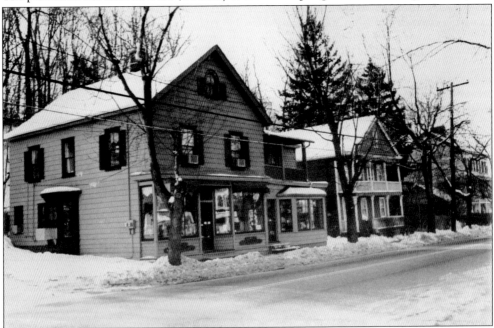

This house next to the municipal parking lot has been expanded and modified over the years. In the early 1900s, it was owned by Ed Holmes, who supervised the construction of the Walter Jennings estate, Burrwood. His wife operated a bakery here. Their daughter Mary Jane leased the shop for use as the local post office. Mary Jane later donated the land for the Cold Spring Harbor Whaling Museum and became its assistant curator. (Courtesy of the Huntington Historical Society.)

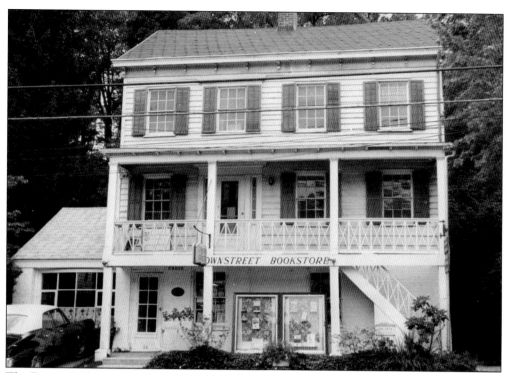

The Denton-Valentine House was built in the 1850s for Andrew Jackson Denton and his bride, Abigail Valentine. After Abigail died in 1885, the downstairs was a bakery run by Maggie Brown. She rented upstairs rooms to local ministers. Once, she rented a room to the son of the lighthouse keeper so he could attend school. In 1960, Cold Spring Harbor's first and only bookstore opened here. This end of the village, where the commercial establishments were located, was called "downstreet." To the east, where the larger houses were located, was "upstreet." The bookstore was appropriately named the Downstreet Bookstore. (Courtesy of the Huntington Historical Society.)

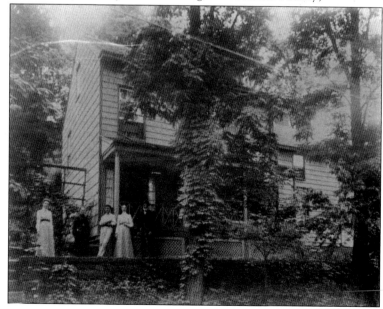

The Israel Valentine House stood next to the Denton-Valentine House. Pictured here are members of the Pedrick family, who lived in the house when this photograph was taken. The house later fell into disrepair and was demolished in the 1940s. (Courtesy of the Huntington Historical Society.)

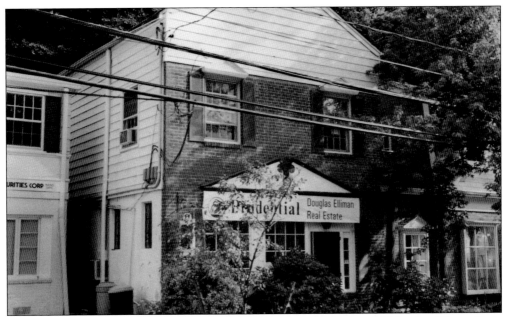

William Bloemecke constructed two buildings on the site of the Israel Valentine House. Each building had office space downstairs and an apartment on the second floor. The building, at 44 Main Street, was a Daniel Gale Real Estate office and then a Prudential Douglas Elliman office. In 2003, when the building was converted into a beauty salon, the facade was modified to its present Greek Revival appearance (below). When this building was originally constructed in the 1940s, there was no historic preservation code in the town of Huntington. During the 2003 renovations, the Town Historic Preservation Commission used its review over buildings in historic districts to guide the development of plans so they would be in keeping with the historical character of the Cold Spring Harbor Historic District. (Both, courtesy of the Huntington Historical Society.)

In the 1880s, George Bennett, who had been the town miller, and Henry T. Seaman operated a store at Seaman's Dock. That store burned down in 1896—the first fire in the newly formed fire district. After the fire, the partnership was dissolved. The following year, Bennett built this house for his grocery and feed store. He and his family also lived there. In 1906, Bennett sold the store to Stephen Pedrick, who had worked in the store since 1892. The house was demolished in 1969 to accommodate the expansion of the firehouse. (Courtesy of the Huntington Historical Society.)

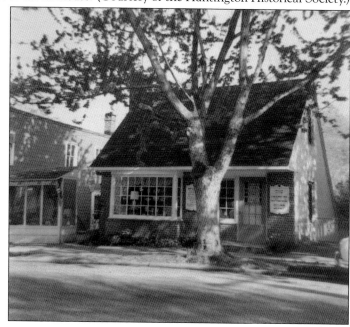

Joseph Velsor opened a butcher shop in Huntington in 1868. Five years later, he moved his shop to this building at 37 Main Street. He lived in the building next to it to the east. Velsor also served as justice of the peace for the Town of Huntington. After he died in 1911, his son Harry succeeded him in the business. (Courtesy of the Huntington Historical Society.)

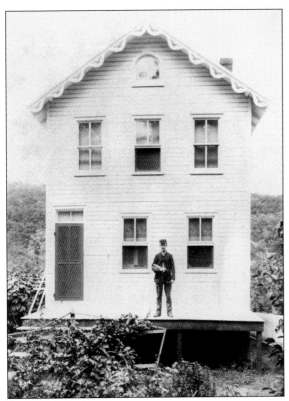

In the photograph at left, Frank Nichols stands in front of his mother's house at 29 Main Street with his cornet, which he played at social functions. His mother, Sarah Jane Price Nichols, was the daughter of Isaac Price, who built the house at 43 Main Street in the 1870s. Sarah and Stephen Nichols came to Cold Spring Harbor with their young family in the 1870s. Their son Frank became a plumber, steamfitter, and tinsmith. In 1898, he extended the house to the front, nearly to the street, and built an addition to the west, creating a double house (below). One store was for Frank's plumbing business, and the other was for his brother's bicycle repair shop. (Both, courtesy of the Cold Spring Harbor Whaling Museum.)

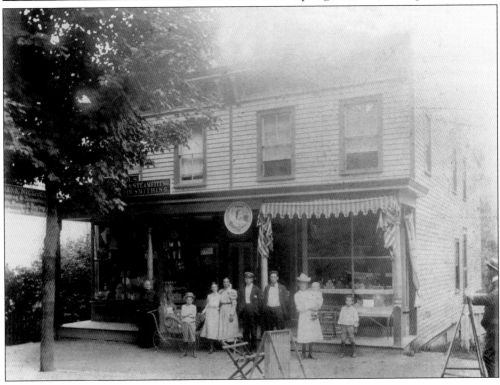

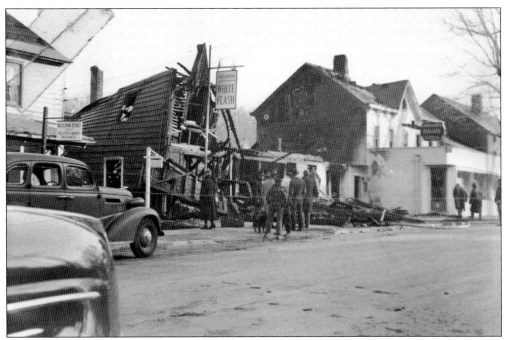

White's Hotel was destroyed by fire in 1940 and replaced by the current building at 55 Main Street. The 1940 building originally housed the post office and a hardware store. After the post office moved to its current location in 1962, the building was converted to a restaurant; first Wyland's Country Kitchen, then Bedlam Street. (Courtesy of the Cold Spring Harbor Whaling Museum.)

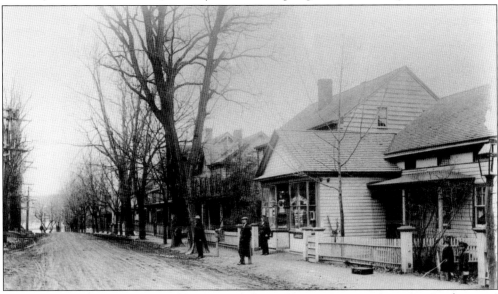

In 1858, this building was owned by Capt. William Clinton Brown, whose daughter married William S. Keene. The Keenes operated a store here that included the village's first ice cream shop. It was probably during their tenure that the storefront on the west end of the building was added. The taller building immediately next to the Keene Building is the oldest surviving building on Main Street. By the middle of the 19th century, it was Seaman's Rail Road Hotel. (Courtesy of the Huntington Historical Society.)

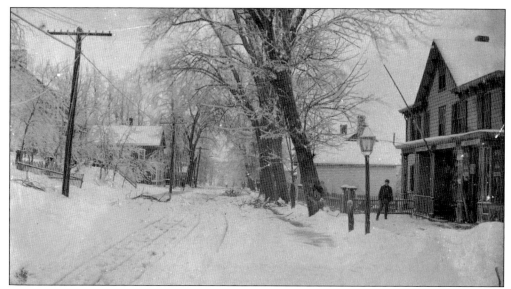

This scene of Main Street looking west in the winter of 1895 shows the Lockwood house and store on the right. On the left, barely visible behind the first telephone pole, is one of the four houses demolished in the early 1960s to build the municipal parking lot. (Courtesy of the Cold Spring Harbor Whaling Museum.)

In 1869, James H. Lockwood returned to his hometown from Brooklyn and opened a grocery store in this building, in which he also lived. After he died in 1884, his son William operated the store until he retired in 1918. It continued as a grocery store until the late 1950s, when Vera Lazuk moved her art gallery from Fort Salonga to the vacated grocery store. (Courtesy of the Huntington Historical Society.)

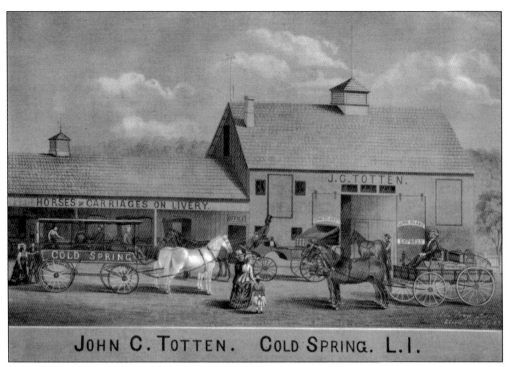

JOHN C. TOTTEN. COLD SPRING. L.I.

John C. Totten came to Cold Spring Harbor from Brooklyn shortly after the Civil War. At first, he worked as a real estate broker, and later, he opened a livery stable on the north side of Spring Street, near the pond. In addition to carrying the mail to and from the train station, he would ferry passengers to the station and provide carriages for guests at the summer resorts for excursions through the countryside. His son William continued the livery business until 1916. (Courtesy of the Society for the Preservation of Long Island Antiquities.)

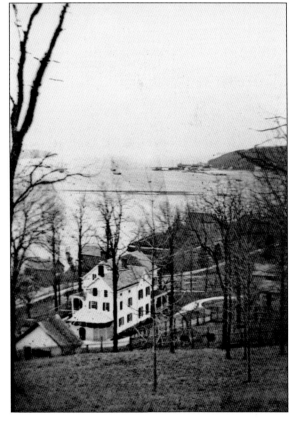

From this perspective, it is easy to see why the white house in the foreground was named Harbor View. It was the home of Jacob C. Hewlett, the surveyor of the port. (Courtesy of the Huntington Historical Society.)

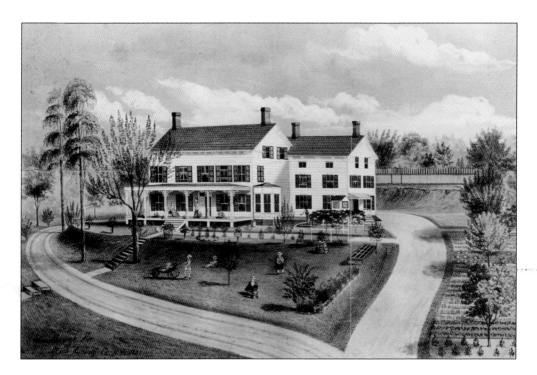

Artist Edward Lange was a German immigrant who was active on Long Island in the 1870s and 1880s. He was hired to paint the homesteads of prominent residents. He also painted vignettes of harbors and villages to be photographed for reproduction and sale. In 1881, Lange painted Harbor View (above). The photograph below shows the house unchanged some 40 years later. (Above, courtesy of the Huntington Historical Society; below, courtesy of the Cold Spring Harbor Whaling Museum.)

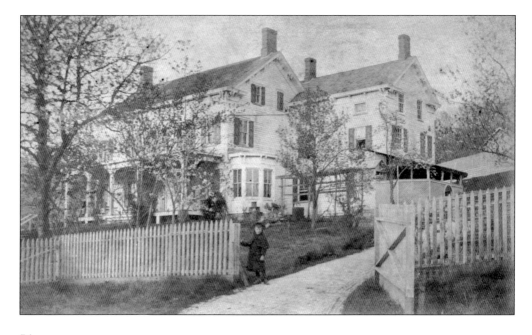

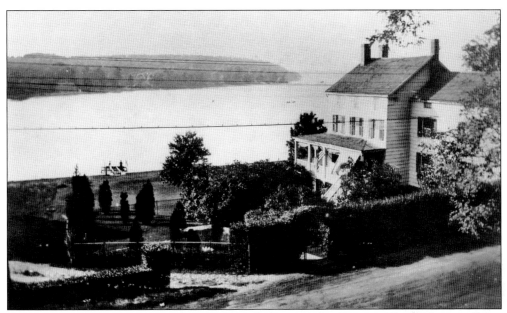

This house was built around 1810 by John Jones for his son John H. Jones. The 1790 gristmill was located about 200 feet south of this house, and the Jones & Hewlett General Store was between those two buildings. This property was the hub of the Jones family industries, including their whaling ventures. The house is now owned by the Cold Spring Harbor Laboratories and provides housing for lab scientists. (Courtesy of the Huntington Historical Society.)

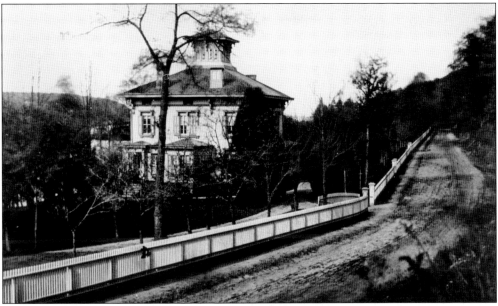

Townsend Jones, son of John H. Jones, was considered one of the ablest auctioneers in New York City. He had this house built around 1855. His son Joshua Thomas Jones was engaged in chemical manufacturing in Vermont and worked at the Atlantic Mutual Insurance Company. In 1890, Joshua returned to the family homestead. He died in 1905. His brother Townsend, a lawyer in Manhattan, had the house remodeled in 1914 and made it his summer residence. (Courtesy of the Huntington Historical Society.)

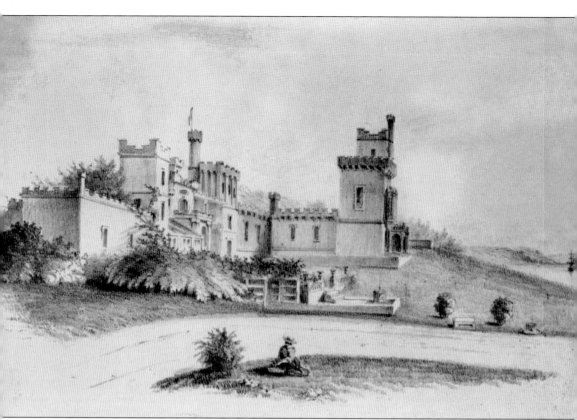

John Banvard was a world-famous artist who made a fortune exhibiting his panoramic paintings of the Mississippi River. Two long canvases were rolled from one spool to another on either side of the audience, giving the illusion of a trip down the river. It was said that the paintings were three miles long, which is probably an exaggeration. After a successful European tour in the 1840s, which included a private viewing of his panorama painting for Queen Victoria, Banvard came to Cold Spring Harbor and built this castle-like home, reportedly inspired by Windsor Castle. He named it Glenada in honor of his daughter Ada. The neighbors called it "Banvard's Folly." The castle stood up the hill from the present site of the Cold Spring Harbor Beach Club. (Courtesy of the Huntington Historical Society.)

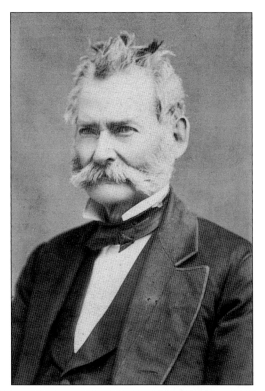

Near Banvard's castle was the more modest home (below) of local painter David Rogers (right), located across from what is now the entrance to Eagle Dock Beach. Rogers studied with John Vanderlyn, a successful artist in New York. Vanderlyn's *Panoramic View of the Palace and Gardens of Versailles* is on display at the Metropolitan Museum of Art. Rogers was acquainted with many prominent men of the 19th century and painted a portrait of Pres. Andrew Jackson. Rogers died in 1884. (Both, courtesy of the Huntington Historical Society.)

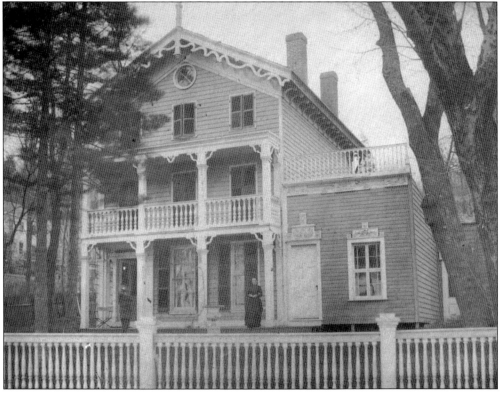

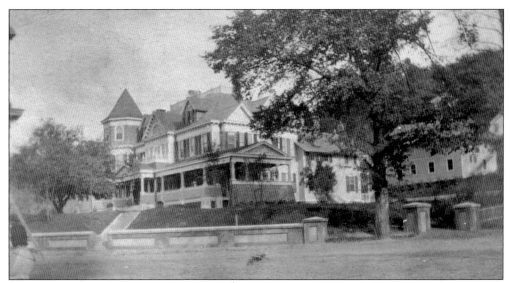

This impressive house was built in 1904 on the site of the David Rogers house. According to the June 10, 1904, edition of the *Long-Islander*, it was built to have all the modern conveniences: "electric lights, hot and cold water, bath rooms, etc." George A. Williams sold the house in 1908 to Walter Jennings and his sister Helen James, the wife of Walter James. They had the house moved north, near the former location of the Forest Lawn Hotel. It was partially destroyed by fire in 1918. The undamaged portion was subsequently demolished. (Courtesy of the Huntington Historical Society.)

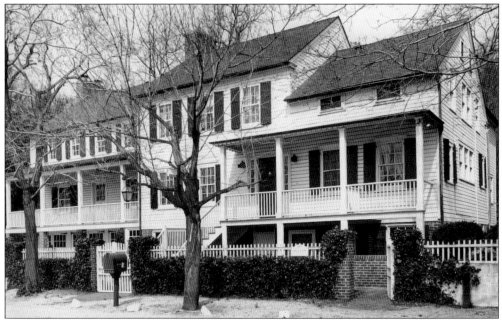

In the early 20th century, this house was known to the locals as "Dirty Dick's" boardinghouse. It was probably named after an 18th-century London merchant who refused to clean himself or his warehouse after the death of his fiancée on their wedding day. A widowed dressmaker and her son lived here and took in bachelor boarders during the summer months. (Courtesy of the Huntington Historical Society.)

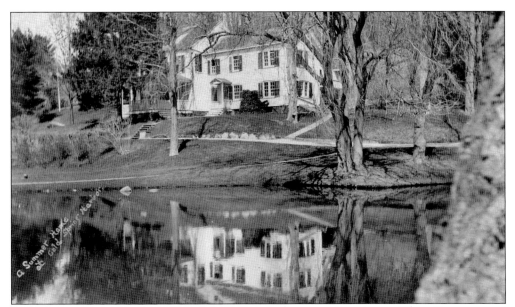

The original section of this house was built before the American Revolution. Henry Titus acquired it in 1797. Following a lengthy and contentious probate proceeding, the property was eventually acquired by George Mowbray in 1870. In 1873, Henry G. DeForest purchased the house and started accumulating the surrounding properties. (Courtesy of the Huntington Historical Society.)

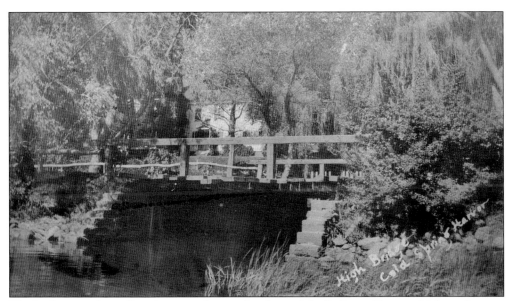

The bridge over the spillway between the pond in front of the DeForest House, which can be seen in the background, and the harbor was known as High Bridge. This photograph was probably taken after the planking had been replaced in 1915. (Courtesy of the Cold Spring Harbor Library.)

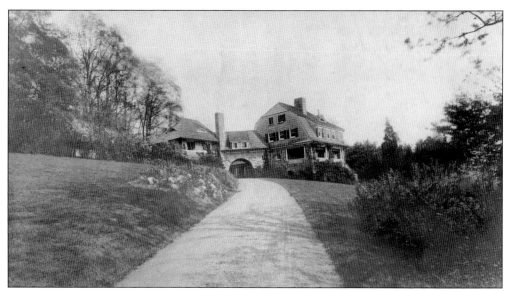

Henry DeForest's son Robert had the house seen in these photographs built in 1898, just up the road from his father's summer cottage. Architect Grosvenor Atterbury was instructed to create a house that looked like a Long Island summerhouse but also gave the impression of an Adirondack hunting lodge. The estate, named Wawapek, included over 100 acres stretching up the hill and over to Goose Hill Road. Over the years, most of the land has been subdivided and developed. Recently, the family sold 32 acres to a consortium comprised of Suffolk County, the Town of Huntington, and the North Shore Land Alliance. Six acres, including the house, remain in the DeForest family. (Above, courtesy of the Huntington Historical Society; below, courtesy of the Society for the Preservation of Long Island Antiquities.)

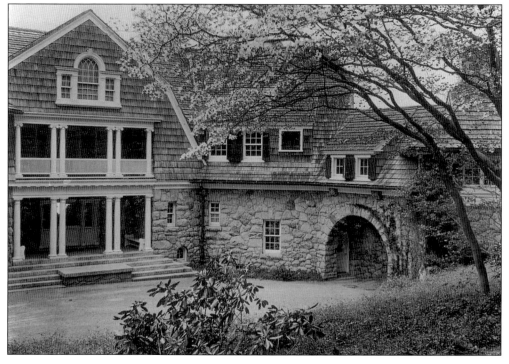

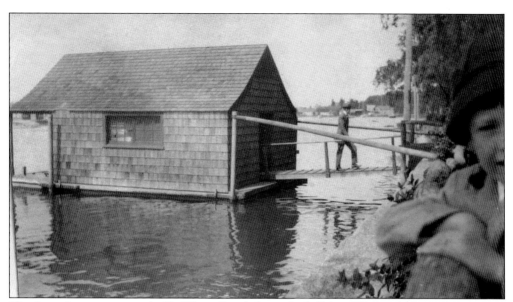

This houseboat was moored off of Shore Road, down the hill from Wawapek. In it, the DeForest family stored rowboats and canoes that were used to get out to the sand spit. There were also several small storage buildings on the sand spit for boating equipment. The DeForest yacht *Priscilla III* was moored off the sand spit as well. (Courtesy of the Huntington Historical Society.)

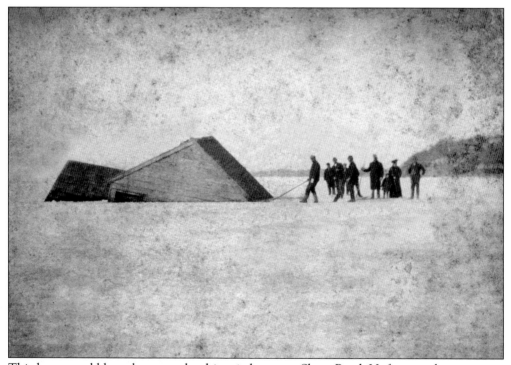

This house could have been another historic home on Shore Road. Unfortunately, contractor Thomas Doran's plans to move it across the frozen harbor in 1888 were unsuccessful. (Courtesy of William Ahern.)

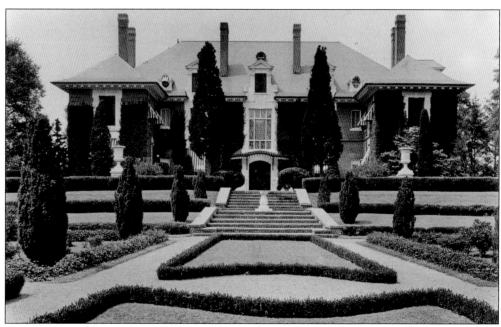

Walter Jennings, of the Standard Oil Company of New Jersey, purchased a large tract of land overlooking the harbor in the late 1890s. He gave his architects a picture of a house in England he admired as a suggestion for the design of their new home, Burrwood, sited on a bluff with a commanding view of the harbor. The sunken garden was located to the east of the house. Almost two decades after the house had been completed, Jennings retained the Olmsted Brothers—the sons of Frederick Law Olmsted, the designer of Central Park—to design additional gardens between 1916 and 1938. Jennings died in 1933. After his widow died, the property passed to his son, who sold it to Helen Keller Services for the Blind, which operated the Industrial Home for the Blind there from 1952 to 1985. The mansion was demolished in 1993, and the remaining 34 acres were subdivided. (Above, courtesy of the Society for the Preservation of Long Island Antiquities; below, courtesy of the Huntington Historical Society.)

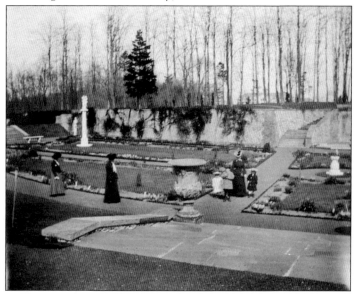

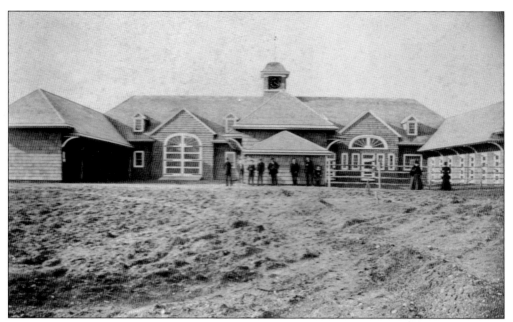

Like many of the great estates of the era, Burrwood was also a working farm. The elaborate brick farm complex at Burrwood was designed by little-known architect J. Clinton Mackenzie. Initially, the estate contained 250 acres, but it was later expanded to more than 1,000 acres. (Both, courtesy of the Huntington Historical Society.)

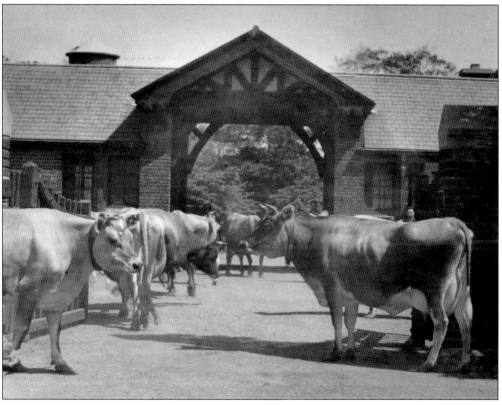

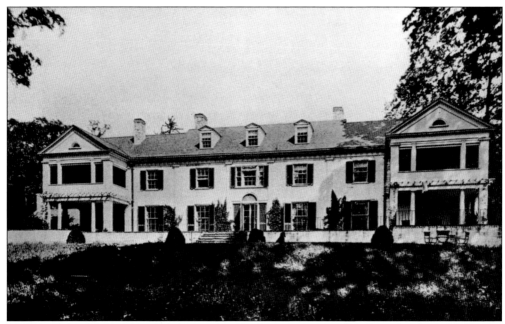

In 1923, Walter Jennings deeded 9.5 acres near his home to his daughter Jeanette, the wife of Henry C. Taylor. There they built Cherridore, a whitewashed-brick Colonial Revival house. The property had been the site of the Glenada, which had been demolished in 1906 (see page 78). Cherridore still stands today. (Courtesy of the Society for the Preservation of Long Island Antiquities.)

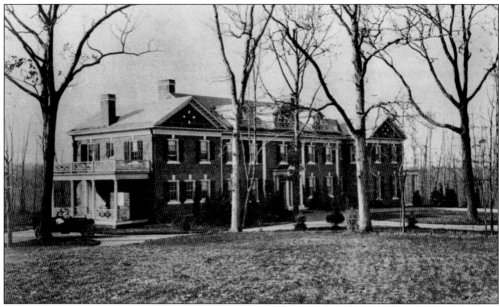

Effingham Lawrence had this home built on a hill overlooking the head of the harbor between 1909 and 1911. Lawrence sold the 80-acre estate in 1920. It was soon acquired by George Nichols and his wife, the daughter of J.P. Morgan. Today, the mansion is in private hands and most of the property is owned by the Nature Conservancy. Although Lawrence owned the property for only a short time, the road on which the property sits, Lawrence Hill Road, is named for him. (Courtesy of the Society for the Preservation of Long Island Antiquities.)

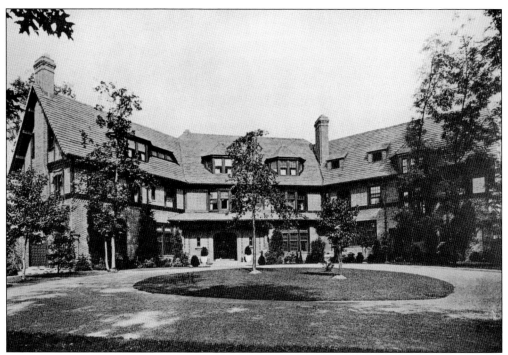

Across a gorge to the south of the Lawrence property, Charles A. Peabody built his mansion at the same time Lawrence did. Peabody was the president of the Mutual Life Insurance Company. His son Julian became an architect, whose local commissions included Huntington's first town hall (1910), the Cold Spring Harbor Library, on Shore Road (1913), and East Side School (1925). This house was destroyed by fire in 1978. (Both, courtesy of the Society for the Preservation of Long Island Antiquities.)

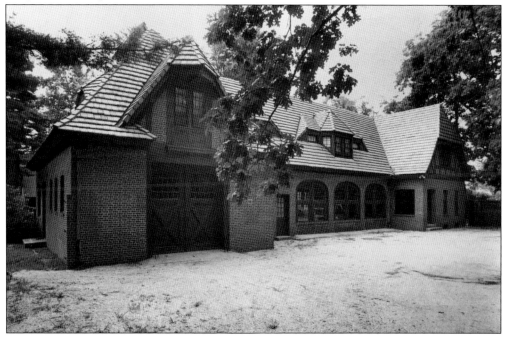

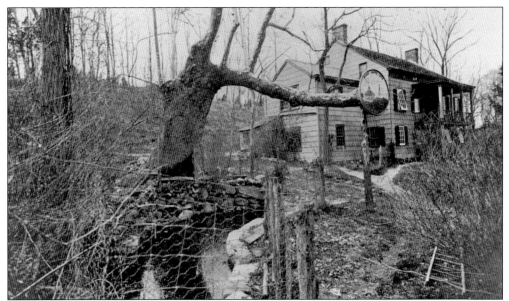

The Rogers family owned much of the land in the valley through which Turkey Lane now runs. In fact, the road used to be known as Rogers Avenue. This is probably the site where Jonathan Rogers built his log house in the 1680s. It was replaced about 1820 by this house, which remained in the Rogers family until around 1908. George Washington supposedly stopped to drink from the spring shown above during his tour of Long Island in April 1790. He was on his way to Oyster Bay from lunch at the Widow Platt's Tavern, located on Park Avenue in Huntington. Turkey Lane would have been the preferred route to avoid the steep hill on Lawrence Hill Road. In the 1920s, the house was sold to Archibald Roosevelt, the son of Pres. Theodore Roosevelt. (Both, courtesy of the Huntington Historical Society.)

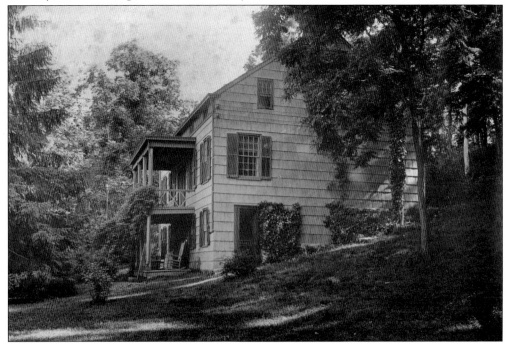

Robert T. Hunn, "the Sage of Turkey Lane," was well known and respected for his weather-forecasting abilities. Picnics and outings were scheduled according to "Professor" Hunn's weather predictions. The self-styled professor (right) had many careers, including wolf hunter, telegraph operator, and fire extinguisher salesmen, but he was best known for his "copper core steel cable conductors," or lightning rods. His advertisements not only boasted that his lightning rods had "never failed to protect," they also included an endorsement from Thomas Edison. By the early 20th century, he was living in the house pictured below, which had been the home of Zebulon Rogers. The house, which is at the entrance to Cold Spring Harbor High School, was built before 1858 and, according to local lore, was a stop on the Underground Railroad. (Both, courtesy of the Huntington Historical Society.)

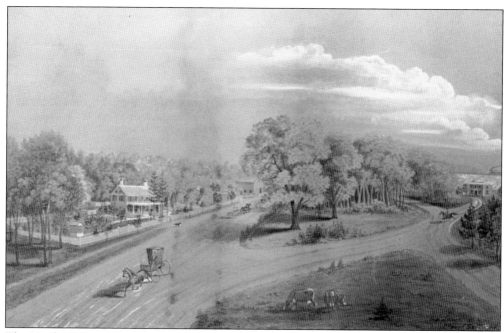

The Hewlett House remains largely the same today as it appears in this 1881 painting by Edward Lange. Before 1817, the house was owned by Anthony Thompson. Jacob C. Hewlett acquired it in 1835, and it remained in the Hewlett family until 1947. On the far right is the Dowden drum factory. Behind the factory is a train leaving Cold Spring Harbor for Huntington. Lange liked to include trains in his paintings whenever he could. (Courtesy of the Huntington Historical Society.)

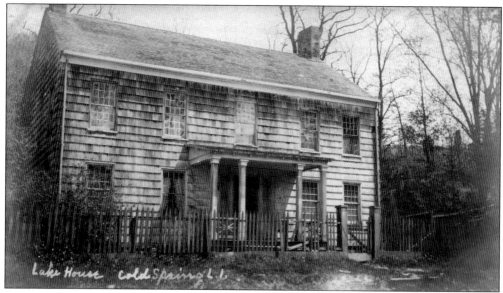

The Lake House stood on the east side of what was then known as the Depot road (now Harbor Road), across from the dam for the second lake. Philo Jarvis moved here in 1895. About five years later, he began taking in boarders. He and his wife moved to Huntington in 1913 and then to Florida. (Courtesy of the Huntington Historical Society.)

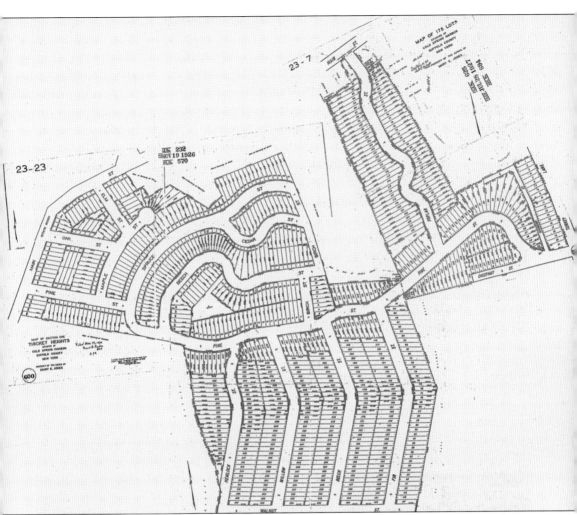

Suburbanization came to Cold Spring Harbor before World War II. In fact, the first subdivision of land for development dates to the early 19th century, when Richard M. Conklin and Moses Rogers starting selling building lots along Main Street; however, the first subdivision that would be recognized as suburban today was filed in 1907. The John Walters property, at the southeast corner of Main Street and Turkey Lane, was divided into 38 lots, and three new streets were laid out. In 1922, Harbor Terrace was subdivided. A few years later, Rosalie Jones filed three different maps—shown here combined—to develop land that had been in her family for years. The plan provided for almost 900 lots, each 20 feet to 40 feet wide. Only a small section of this plan was ever realized. Much of the land was later acquired for the high school, and other sections were subsequently developed pursuant to a different plan. (Courtesy of the Huntington Historical Society.)

The hilltop area between Cold Spring Harbor and Huntington was subdivided in 1912 as Cold Spring Hill. That effort floundered, and a certificate of abandonment was filed in 1941. The project was then resurrected that same year as Harbor Ridge, the entrance of which is seen above. The 120-home development encompasses 57 acres of the former Titus and Walters farms. About 750 people, including town, county, and state officials and representatives of mortgage companies, attended the dedication of the new development in September 1941. Below, the head of the development company, Harry Schumacher, cuts a congratulatory cake as part of the celebration. (Both, courtesy of the Huntington Historical Society.)

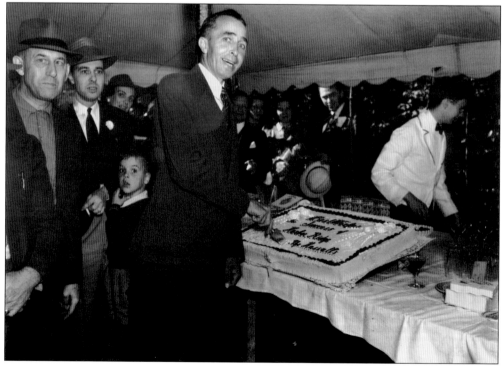

Five

HOMETOWN HOSPITALITY

Following the demise of the whaling industry and the slow decline in milling, Cold Spring Harbor's economy was sustained by tourism. Even with all the industrial development along the harbor's shores, Cold Spring Harbor remained an idyllic place, especially for New Yorkers trying to escape the city's heat in the days before air conditioning.

Cold Spring Harbor's hotels, however, predate the Gilded Age. In the 1840s, during the height of the whaling industry, there was a need for hotels for laborers, sailors, and traveling salesmen. Noah Seaman operated his Seaman Rail Road House in the middle of the village on Main Street. Abraham Walters operated a hotel on the shore between the gristmill and Noah Seaman's store. The most notorious was William Post's, which closed down in 1848, leaving an observer in a letter to the editor printed in the May 15, 1848, edition of the *Long-Islander* to wonder how long it would take before "the tide of dissolute and abandoned rummies had in some degree ceased to set that way."

Later in the 19th century, summer resorts welcomed New Yorkers to Cold Spring Harbor's shores. Picnic groves welcomed thousands of day-trippers, who arrived by steamboat for short summer outings. Summer resort hotels were so important to the local economy that when it was announced that they would be closed, some people told the *Long-Islander* in its May 24, 1901, issue that they feared it would "mean the ruin of the village."

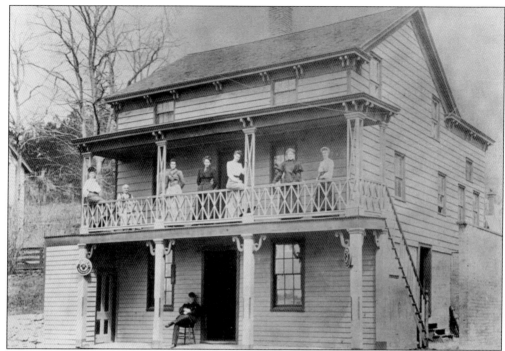

In the 1850s, Abraham Walters, operated a hotel near Seaman's Dock. In 1863, his daughter Sarah, who had previously been married to a man named Place, married George Van Ausdall. Van Ausdall took over the hotel from his brother-in-law George S. Walters, who gave up the hotel to engage in coastal trade. Some have interpreted the image above as evidence that Van Ausdall ran a brothel. In fact, it shows Van Ausdall sitting outside the front door of the hotel, while upstairs are, from left to right, family friend Marion Miller, Van Ausdall's wife Sarah; his daughters Ida and Blanche, his daughter-in-law Mabel, and two unidentified women. Van Ausdall's son, also named George, took over operation of the hotel. In the photograph below, motorists stop by for a meal around 1915. (Both, courtesy of the Huntington Historical Society.)

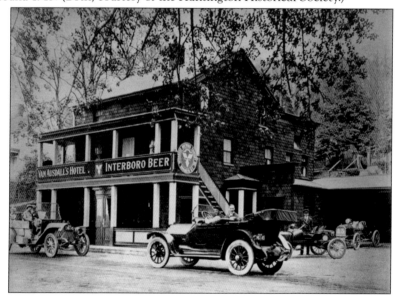

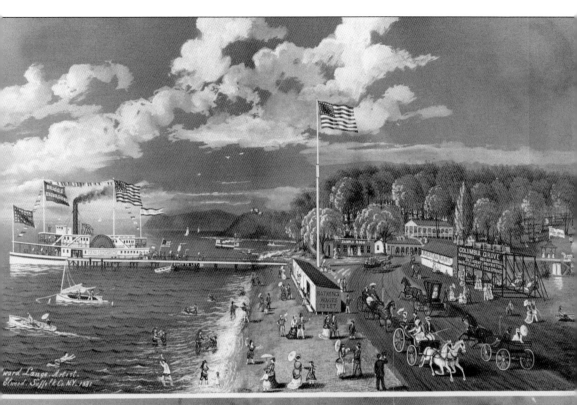

COLUMBIA GROVE.

George Van Ausdall Sr. opened Columbia Grove in 1878 at the entrance to Lloyd Neck. John Nelson Lloyd first constructed a steamboat dock here in 1837. The dock was primarily used to load cargo. But, with the advent of the railroad, it was converted for use as a picnic ground. Steamboats filled with hundreds of New Yorkers would arrive during the summer months, and visitors enjoyed boating, swimming, picnicking, carriage rides, and other diversions. (Courtesy of the Huntington Historical Society.)

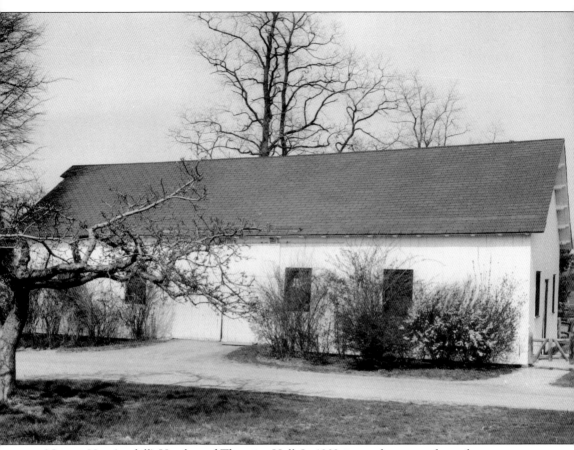

Next to Van Ausdall's Hotel stood Thespian Hall. In 1902, it was the scene of a performance gone tragically wrong. The barber from Van Ausdall's Hotel volunteered to have an apple shot from his head. The showman's shot hit the barber instead of the apple, killing him. The next year, Thespian Hall was dismantled, and the wood was used to build this barn at the Joshua T. Jones farm, now the Nature Conservancy's Uplands Farm. (Courtesy of the Huntington Historical Society.)

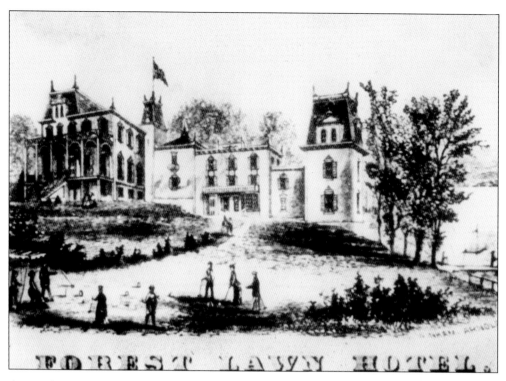

FOREST LAWN HOTEL.

Artist John Banvard built the Forest Lawn Hotel (above) in 1873, about 300 feet south of his castle. The "plain but comfortable and well-furnished boarding house" sat on 40 acres of lawns and forest, offering picturesque views of the harbor as well as facilities for fishing, boating, and bathing. In 1882, C.B. Gerard acquired both the Forest Lawn Hotel and Banvard's castle, Glenada, which he enlarged and converted into a summer resort hotel with over 300 rooms. The photograph below shows the Glenada Hotel after it had been converted into its new function. Both buildings were demolished in 1906 after Walter Jennings acquired the property. Today's Snake Hill Road runs between the sites of the two buildings. (Above, courtesy of the Cold Spring Harbor Whaling Museum; below, courtesy of the Huntington Historical Society.)

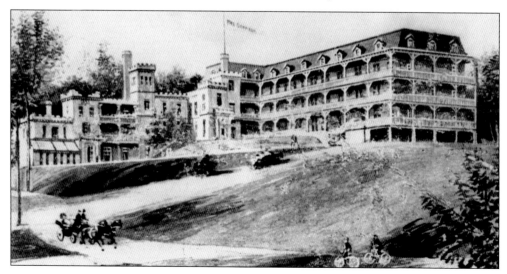

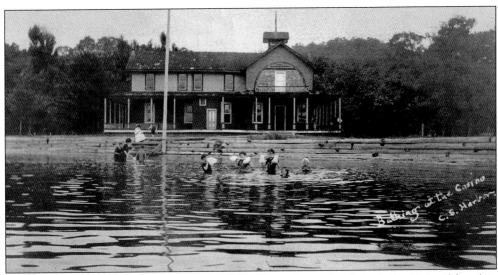

William Gerard, the proprietor of the Glenada and Forest Lawn Hotels, built the Casino (above) in 1888. The building was used to provide hotel guests with a place for dancing and billiards. He also built two other structures nearby (below). One featured a bowling alley, bathing apartments, and 10 bachelor apartments. The other included horse sheds and 20 additional bachelor apartments. The Casino became the social focus of a stay at Cold Spring Harbor's two resort hotels. An 1889 article in the *New York Times* described the scene thusly: "The Casino is a great institution. Here music hath charms in the season and the clink of the billiard balls mingling with the mellifluous jangle of crushed ice and the long straws while the breezes blow away the heat of the city from the fevered brow of business manhood and play havoc with the carefully-prepared tresses of the winning sex." (Above, courtesy of the Cold Spring Harbor Library; below, courtesy of the Cold Spring Harbor Whaling Museum.)

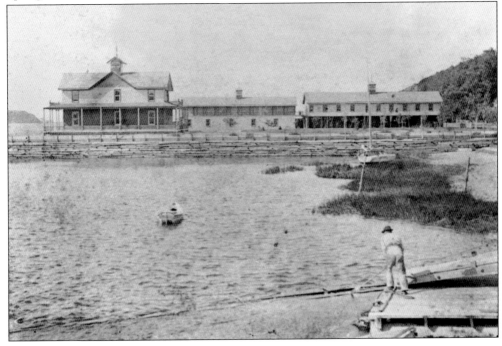

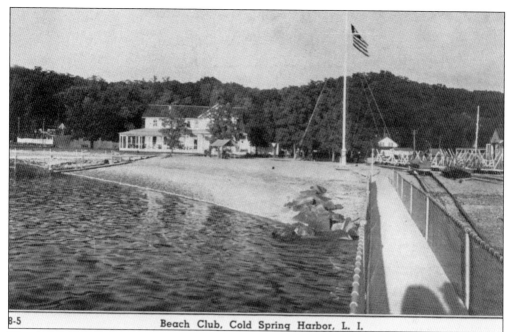

Beach Club, Cold Spring Harbor, L. I.

The Casino is the only surviving structure of the Gerard hotels. Gerard sold the resort properties to Walter Jennings and his sister Helen James in 1901. They demolished the hotel buildings in 1906, but they kept the Casino and made it available to local groups. In 1921, the Cold Spring Harbor Beach Club was formed, and it leased the Casino property. The club later acquired the title to the property. (Courtesy of the Cold Spring Harbor Whaling Museum.)

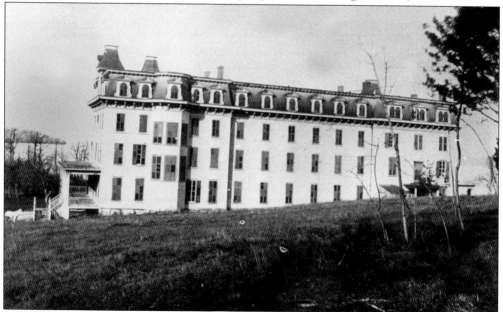

The Laurelton Hotel, the first of Cold Spring Harbor's summer resorts, was on the west side of the harbor. It was owned by Dr. Oliver Jones and operated by the Gerard family before they purchased the Forest Lawn and Glenada property. Louis Comfort Tiffany later built his mansion on this site. (Courtesy of the Huntington Historical Society.)

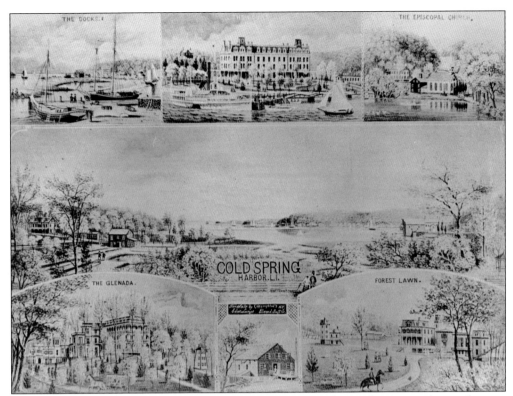

Edward Lange painted these two vignettes of Cold Spring Harbor, reflecting its change from an industrial port to a summer resort area. An illustrated Long Island Rail Road timetable of 1877 pointed out the "ample facilities . . . offered by the various hotels and boarding houses . . . where are bathing houses and innumerable small craft for the pleasure and convenience of guests . . . Near the head of the harbor, but almost hidden in the abundant foliage, are barely visible the ruins of once extensive factories; and beyond, up the valley, separated from the salt water by dam, are a series of fresh lakes, which, sparkling in the sunshine, with rich foliage of the woods reflected in their apparently unfathomable depths, forms one of the most attractive drives on the Island." (Both, courtesy of the Huntington Historical Society.)

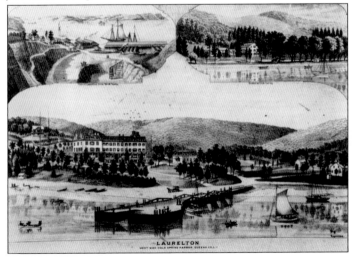

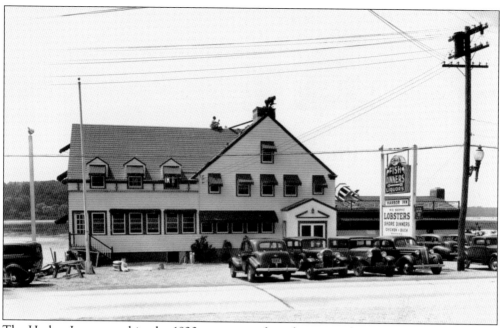

The Harbor Inn opened in the 1920s on a waterfront lot on Harbor Road. The building was partly located over underwater land leased from the Huntington Board of Trustees. In 1947, Emil "Bubay" Siegel took over the restaurant and renamed it the Mooring, (sometimes referred to as the Mooring on the Sound). Of the restaurants in Cold Spring Harbor, it was considered the best. A devastating fire in 1968 burned the restaurant to the water line. Siegel submitted plans to rebuild, but the board of trustees would not renew his lease, depriving him of the space he needed to provide sufficient parking. The loss of the building led to efforts to remove the commercial establishments along the waterfront and create a park. Those plans were considered too expensive when first proposed in 1974; today, they have still been only partly realized. (Both, courtesy of the Huntington Historical Society.)

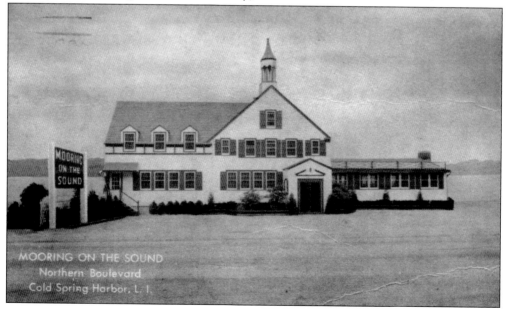

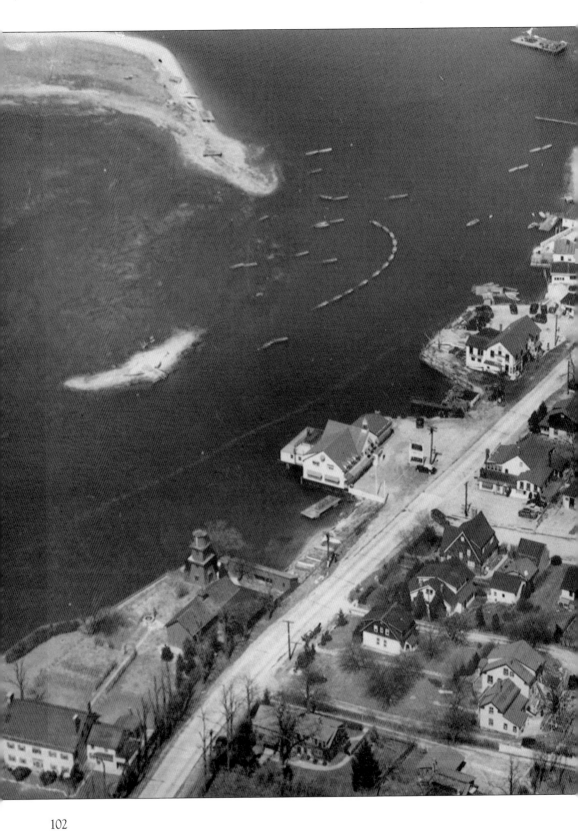

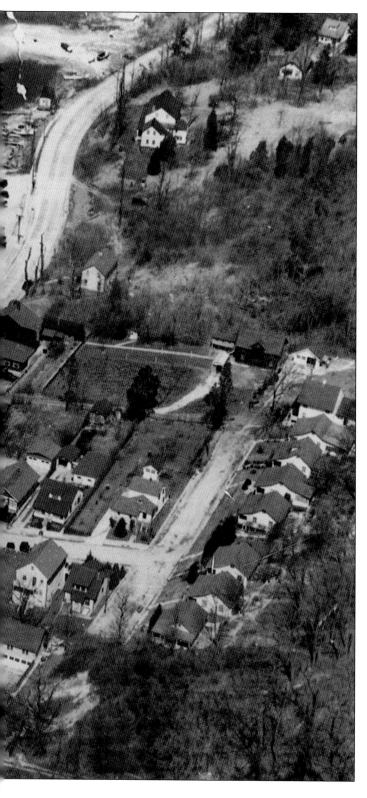

In the mid-20th century, Cold Spring Harbor's waterfront was home to high-end restaurants and clam bars. Looking north along Harbor Road (Route 25A), Van Ausdall's Hotel is in the middle right. Two doors down was the restaurant of Leo Gerard, the son of the proprietor of the Glenada and Forest Lawn Hotels. Across the street, along the water, was the Harbor Inn. Next was Van Ausdall's garage. After World War I, Harry Powles and his brother Milton opened Veterans Fishing Station, where they sold and repaired boat motors. The buildings were destroyed by fire in 1988, but the marina business continues today in a new building. The next business was a clam bar run by the Pappalardo family. Just south of the boat ramp had been Sam Walters's Cold Spring Oyster Farms. In 1954, it was converted into a restaurant, Joe's King Neptune. Restaurant reviews claimed the view was better than the food. The building was leveled in 1976 as part of a park development project that was never fully realized. Next was a clam bar operated by the Arato family. The houses on the right were part of the Harbor Terrace development. Many of the bungalows were summer rentals in the early years. The houses to the far right were demolished or moved after the state condemned the land for a parkway to Caumsett Park. The parkway was never built; instead, the library now occupies this property. (Courtesy of the Huntington Historical Society.)

TROOP "C" CAMP. HUNTINGTON, L. I.

The Brooklyn-based Squadron C Cavalry Club purchased 82 acres of land on Cold Spring Hill in 1905 to establish a summer escape from the city heat, not only for the members, but also for the club's horses. Bisected by today's Donovan Drive, "the Farm," as it was called, featured a clubhouse and a mess hall as well as sleeping huts, stables, a handball court, a polo field, a baseball field, and a riding rink. After World War II, members continued to visit the Farm on an informal basis. The property was subdivided into home lots in 1964. (Both, courtesy of the Huntington Historical Society.)

Mess. Hall, Squadron "C." Camp, Huntington, L. I.

Interior of Club, Squadron C Camp, Huntington, L. I.

Published by D. W. Trainer, Huntington, L. I.

The interior of the clubhouse featured this stone fireplace, which still stands in the backyard of one of the houses built after the Farm was developed. It was said that Pres. Theodore Roosevelt used to sit on the front porch of the clubhouse and swap lies with the club members. (Courtesy of the Huntington Historical Society.)

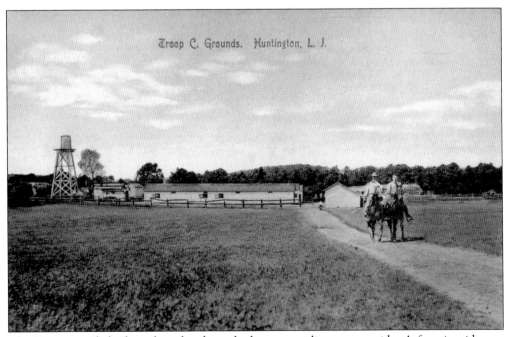

Troop C. Grounds. Huntington, L. J.

The Farm provided a base for rides through the surrounding countryside. A favorite ride was across neighboring farms down to Melville, where the riders would stop for lunch and a glass of beer before heading back. (Courtesy of the Huntington Historical Society.)

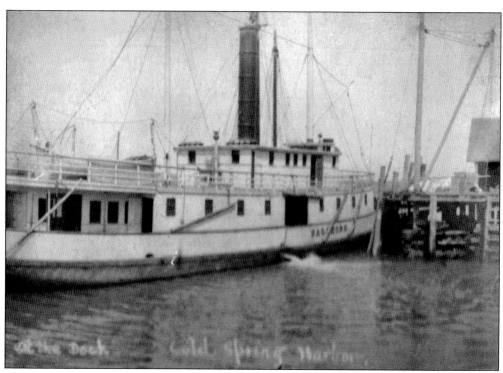

The first steamboat dock on the east side of the harbor, situated near Middle Beach, was built in 1837. It was supplanted by Lloyd's Dock in the 1850s, but it was rebuilt by Dr. Oliver Jones in 1885. The new dock became a convenient point of entry for summer visitors arriving by steamboat. It also provided excellent fishing for local residents. Located next to the Abrams shipyard, the area was industrial as well as recreational. Sail lofts, a lumberyard, and an icehouse mingled with a dance pavilion and a bowling alley. After World War II, the area was slated for further development. (Both, courtesy of the Huntington Historical Society.)

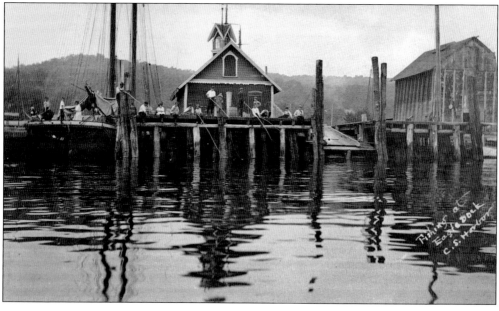

The old War World I subchasers (see page 42) became an attraction for local residents. Here, Margaret Gildersleeve (far left in both photographs), Margaret Kaylor, and Edgar Shadbolt pose on the deck and peek out from a hatchway of one of the ships. Margaret (Gildersleeve) Norton later recorded her recollections of many trips to Eagle Dock to swim, including frequent visits to the old subchasers, in *Maggie's Memories . . . A View of Cold Spring Harbor.* On one such visit they found the captain's logbook, which unfortunately was loaned to someone and never returned. (Both, courtesy of the Huntington Historical Society.)

Residents along Shore Road were alarmed by a proposal to develop the Eagle Dock property with concession stands and amusements. In 1948, they formed Eagle Dock Foundation, Inc., to purchase the property and make it available to the residents of Cold Spring Harbor as a bathing beach, as it had been used informally for years. The house in the image below, once used by the captain of the DeForest family's yacht, remained on the beach for a few years but was later razed. The original two-acre beach included only a small section of beachfront. Priscilla DeForest Williams donated the entire sand spit to the Eagle Dock Foundation in 1986. (Both, courtesy of the Huntington Historical Society.)

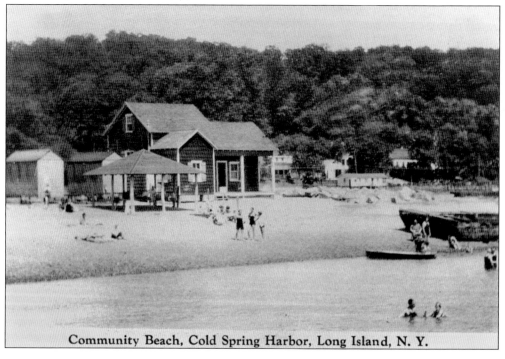

Community Beach, Cold Spring Harbor, Long Island, N. Y.

Near the former location of Seaman's Dock and store is the dock of the Seafarer's Club. The club was formed in 1966 by members of the fire department. Six years later, an independent club was formed. In the distance beyond the dock, the oil tanks on Shore Road can be seen. (Courtesy of the Huntington Historical Society.)

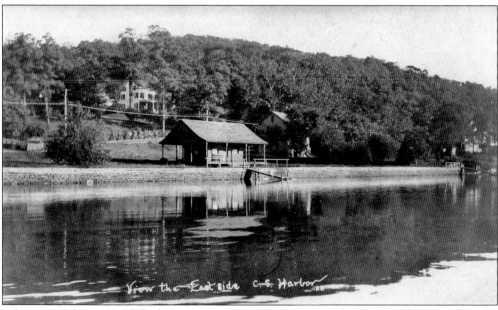

A boating club was established on property that was once part of the Jones holdings, south of the gristmill site. Some residents feared that the potential expansion of the club from 50 slips to 100 would have a detrimental effect on the historical character of the community. The Cold Spring Harbor Labs, located across the inner harbor, shared that fear, and they arranged to purchase the marina in 1973. It remains a small marina today. (Courtesy of the Huntington Historical Society.)

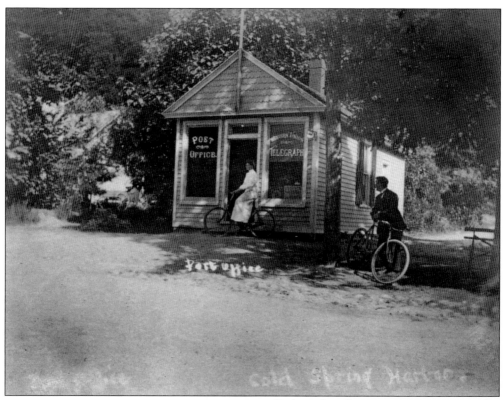

Perhaps few places are more evocative of small-town life than the barbershop. This small commercial building was reportedly moved from Huntington by Dr. Oliver Jones when the owner defaulted on the mortgage. In Cold Spring Harbor, the building (above) has served at various times as the post office, the telegraph office, the library, a candy store, and for many, many years, as a barbershop. The first resident barber was Jack Sloter, pictured at left with his wife, Jennie, on their 55th wedding anniversary in 1949. After Sloter, who was also the custodian at East Side School for 29 years, died in 1952, the shop was run by Sam Ryan. Vinnie Hayes took over from Ryan. Today, Hayes's daughter Jennifer continues the tradition. (Above, courtesy of the Huntington Historical Society; left, courtesy of Jennifer Hayes.)

Six

TRANSPORTATION

The movement of goods and people around, as well as in and out of, Cold Spring Harbor has evolved over the years. Early roads were rutted, narrow, dirt paths. Travel by water was much more efficient. As early as 1837, docks for steamboats were built, first at Eagle Dock and later farther north at Wawapex (now Burrwood, or Jennings Beach) and at Lloyd Neck. Schooners and sloops docked at Seaman's Dock, near the entrance to the inner harbor.

The arrival of the railroad in 1868 greatly improved access to the city and other points on Long Island. As bicycling became more popular in the late 19th century, cyclists advocated for improved roads. Better roads arrived just in time for the automobile to take advantage of them. State aid was sought to improve the two main roads, Main Street (now Route 25A) and the road to the train station (Route 108). Today, of course, all these modes of transportation are still used: boating for pleasure, the railroad for commuting, bicycles for exercise, and the automobile for everything else.

Even though sailing ships had plied Cold Spring Harbor from the Colonial period, a lighthouse was not built here until 1890. The 35-foot-tall wooden lighthouse was built on top of a caisson to mark the shallow waters off of Centre Island. The lighthouse was decommissioned in 1965 and replaced by a day beacon on a metal frame. The building survives, however, on private property on the shore of Centre Island. (Courtesy of the Cold Spring Harbor Whaling Museum.)

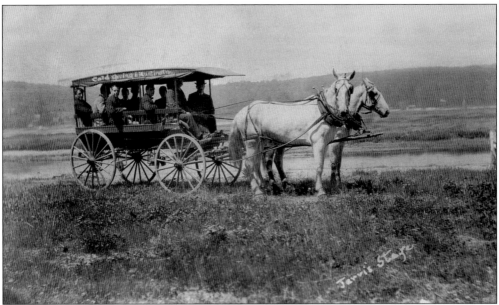

Philo Jarvis, who grew up in Melville, came to Cold Spring Harbor in the 1890s as a carpenter. In 1908, he started a stagecoach route between Cold Spring Harbor and Huntington. The stage made five round-trips a day between the two villages, from 8:00 a.m. to 10:00 p.m. The fare: 10¢ each way. (Courtesy of the Cold Spring Harbor Library.)

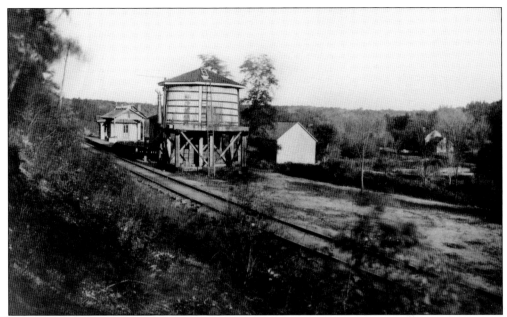

When originally built in the 1840s, the Long Island Rail Road provided a link between Brooklyn and Boston, bypassing the villages along the North Shore. It soon became apparent that the railroad's financial success depended on providing service to those towns. A branch of the main line was extended to Syosset in 1854. Cold Spring Harbor was interested in extending the rails from Syosset to the head of the harbor. In fact, before the Civil War, a right-of-way, which can still be seen today, was cleared and graded along the west side of the valley leading to St. John's Church. The war interrupted those plans. After the war, the route was moved to a location two miles south of the head of the harbor. The station was originally near the intersection of Woodbury and Avery Roads in Nassau County; in 1903, it was moved to its current location. (Both, courtesy of the Huntington Historical Society.)

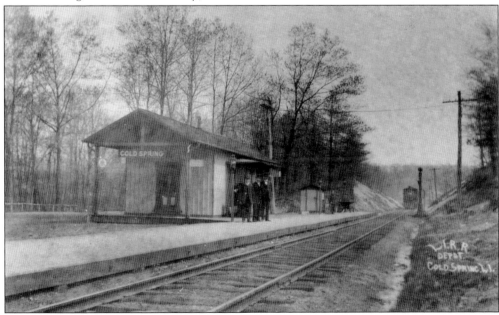

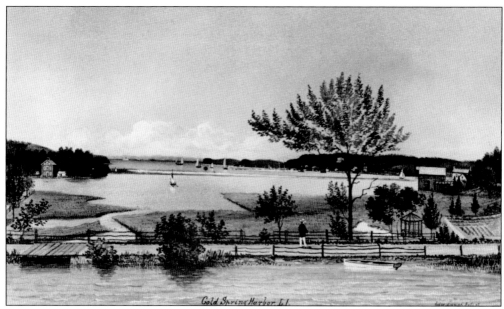

The highway connection between Cold Spring Harbor and Laurel Hollow has changed over the years. Originally, the road ran over the meadow at the head of the harbor. This right-of-way was later converted to a footpath, and the road was moved to run over the dam that formed St. John's Lake, as can be seen in this late-19th-century painting by Edward Lange. (Courtesy of the Huntington Historical Society.)

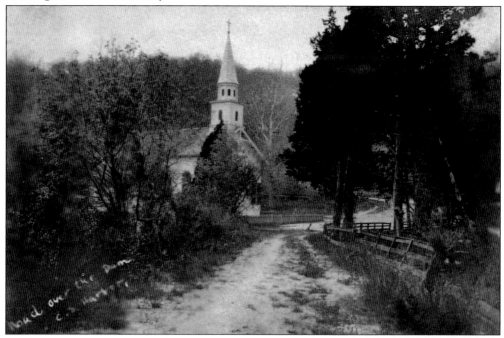

Because the road ran over the dam, the front door of St. John's Church practically opened on to the road. The lake and dam were privately owned by members of the Jones and Hewlett family. They kept the road in good repair, and it was the main route between the towns of Huntington and Oyster Bay. (Courtesy of the Huntington Historical Society.)

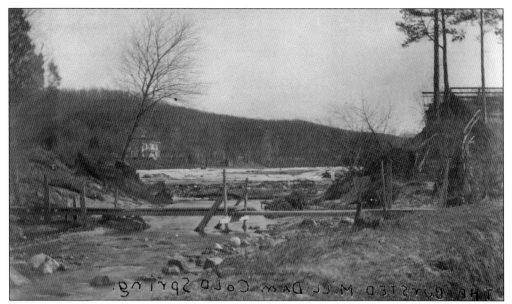

On February 29, 1904, the dam broke. The rush of water washed the bridge down to the gristmill and soon created a breach 100 feet wide and 20 feet deep. The water also dumped large quantities of sand and gravel onto the meadow. The ponds at the fish hatchery were flooded, allowing many fish to escape into the harbor. Town officials immediately began discussing whether to repair the dam or build a new roadway over the meadow. (Courtesy of the Huntington Historical Society.)

A temporary footbridge was quickly built to allow access over the breached dam. This bridge flooded at high tide. Charles Walters, the superintendent of the fish hatchery, ferried people across the stream. Carriages and wagons had to detour south through Woodbury or hazard the snow and ice to get to the upper dam at the second lake. The village milkman even made use of the never-used railroad embankment that ran through the valley. (Courtesy of the Huntington Historical Society.)

The decision to build a new road over the meadow, which was the original route of the road, was more or less settled within a few months. A formal meeting of the highway commissioners of Huntington and Oyster Bay was held in Hicksville in August 1904. The contract for a new concrete bridge was awarded unanimously. (Courtesy of the Huntington Historical Society.)

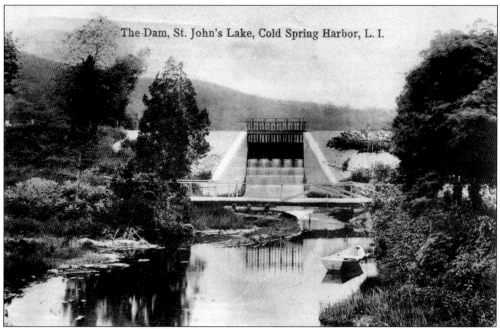

The owners of the lake decided to hire the same contractors to rebuild the dam and a new bridge. The work on both bridges was carried out simultaneously. The iron rail on the bridge over the dam was added in June 1905. (Courtesy of the Huntington Historical Society.)

The expense of the new bridge was shared by the Towns of Huntington and Oyster Bay. Each town was responsible for the road on its side of the bridge. A bridge also had to be built over the canal that supplied water from the lake to the gristmill on the east side of the harbor. In May 1905, the Town of Huntington agreed to allocate $600 for this second bridge. Members of the Jones family, who, after all, owned the mill, and highway commissioner August Heckscher made voluntary donations to raise the additional $1,075 needed for the job. (Courtesy of the Cold Spring Harbor Whaling Museum.)

A horse and carriage rides over the new road heading east. On the right is the main building of the Carnegie Institute. In the distance on the left is the 1887 fish hatchery building. (Courtesy of the Cold Spring Harbor Library.)

The New Road,
Cold Spring Harbor, L. I.

In the late 19th century, bicycling was very popular. Bicyclists, or wheelmen, as they were called, started agitating for better roadways. Their efforts were finally successful in 1898 when New York enacted the Good Roads Bill, also known as the "League of American Wheelmen Bill." Here, the road past the fish hatchery looks in good condition, but the new law did nothing about the steepness of the hill. (Courtesy of the Cold Spring Harbor Whaling Museum.)

Cars travel up the hill from the new road heading west. Jones' Hill is now commonly referred to as Fish Hatchery Hill. (Courtesy of the Cold Spring Harbor Whaling Museum.)

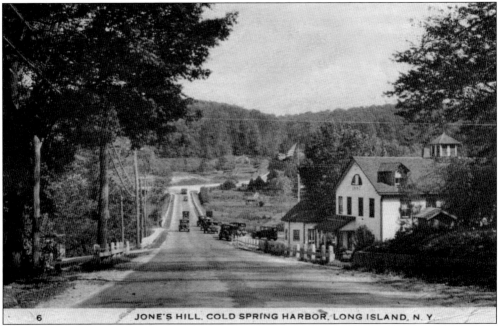

JONE'S HILL, COLD SPRING HARBOR, LONG ISLAND, N. Y.

Seven

EDUCATION

Formal education has a long history in Cold Spring Harbor, and the community is widely known today for its excellent schools. The first public schoolhouse was built in 1790, a quarter century before New York State established common school districts. That 1812 law required towns to set up districts in such a way that children could be conveniently educated. Each of these small districts had its own schoolhouse.

In Cold Spring Harbor, there were two districts, East Side and West Side. The East Side district was bordered by the harbor on the west and extended to what is now the Huntington Country Club on the east. The northern boundary was north of Jennings Road, and the southern boundary was just north of Lawrence Hill Road. The West Side district straddled the county line and included present-day Laurel Hollow and the area in Suffolk County south of the East Side district, as far as just south of the railroad tracks. The eastern border was between Woodbury Road and Oakwood Road. Two more common school districts covered the area that is now the Village of Lloyd Harbor. Lloyd Neck was yet a fifth district.

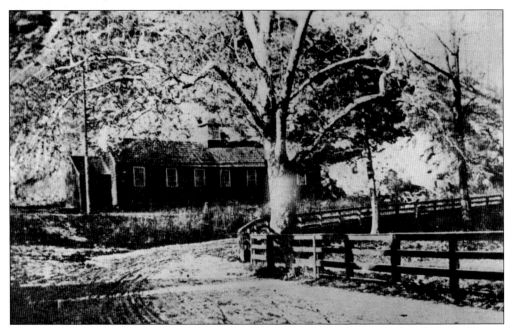

The building of the first schoolhouse in Cold Spring Harbor coincided with Pres. George Washington's visit to Long Island in 1790. After enjoying a hearty meal at the Widow Platt's Tavern in Huntington, the president passed through Cold Spring Harbor on his way to Oyster Bay. As he crossed the meadow at the head of the harbor, he saw workmen erecting a new schoolhouse near where St. John's Church now sits. Legend has it that he assisted in raising one of the rafters and left $1 for the workers. This area was known as Bungtown because of the abundance of barrel stoppers, or bungs, produced in the local barrel factory. The school (below) was, therefore, known as the Bungtown School. It was also called the Nursery of Sea Captains, because so many of its students would take to the sea. (Above, courtesy of the Huntington Historical Society; below, courtesy of the Cold Spring Harbor Whaling Museum.)

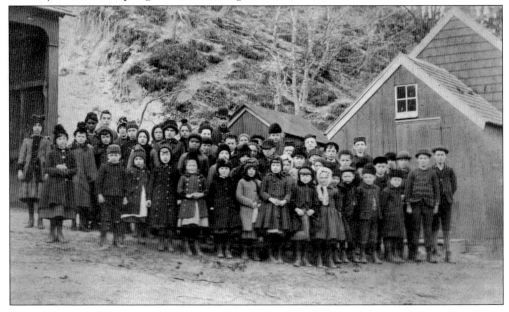

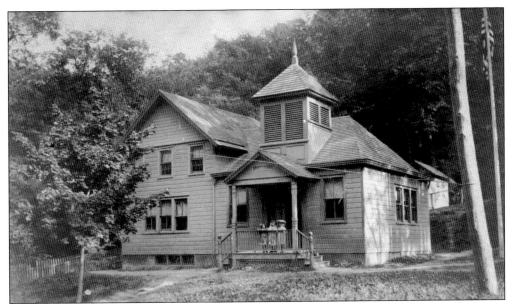

After a century of service, the old schoolhouse was in poor condition. An old tenant house up the hill from the first schoolhouse, across from Moore's Hill Road, was remodeled and enlarged to create this school, which was ready for classes in January 1896. The school served the students of School District No. 11, which included parts of both Huntington and Oyster Bay. (Courtesy of the Huntington Historical Society.)

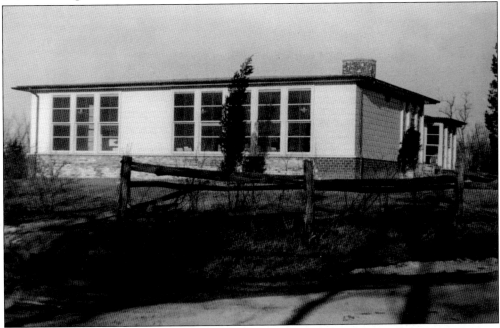

Within 50 years, the second schoolhouse was considered inadequate. The roof leaked, the heat was poor, and the playground was too small. Moreover, the rise of automobile traffic just outside the schoolhouse door presented a danger. The district purchased 4.5 acres from the Bio Labs farther up the hill and built a modern two-room schoolhouse. (Courtesy of the Cold Spring Harbor School District.)

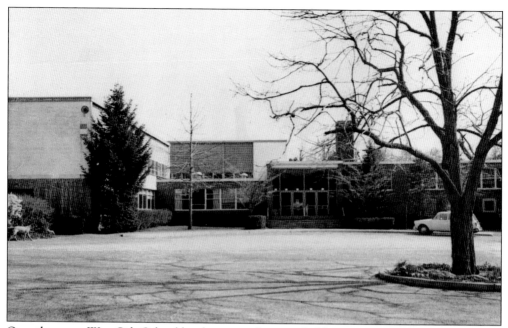

Over the years, West Side School has been greatly expanded from its original two rooms. Those two rooms, each with a fireplace, have remained the most sought-after classrooms in the building. (Courtesy of the Cold Spring Harbor School District.)

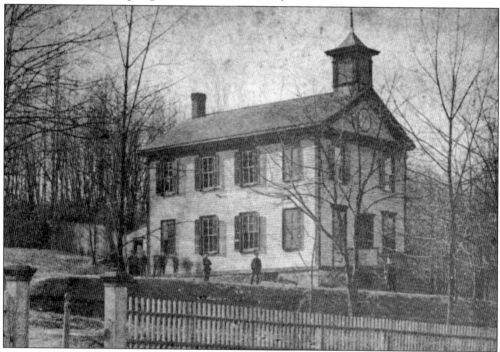

The other Cold Spring Harbor school district, East Side, served children around the village on the east side of the harbor. The first East Side School was built on the north side of Main Street, just west of Goose Hill Road. In the 1870s, a larger schoolhouse was built across the street. The stone wall in front was added in 1873. (Courtesy of the Huntington Historical Society.)

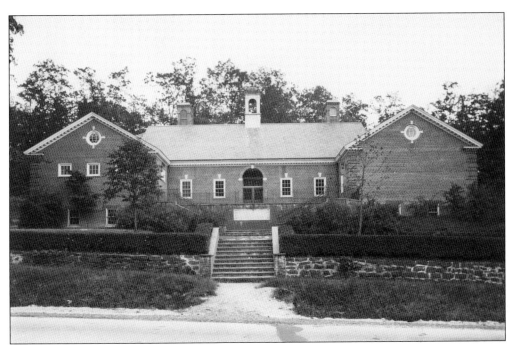

Roughly 14 years after the New York State Board of Education determined that the old school was out of date and ordered a new one built, the residents of the East Side School District dedicated this impressive brick building on the same site as the second schoolhouse. The building included three classrooms, an auditorium with seating for 200, and a large playroom in the basement. The building is now the DNA Learning Center. (Courtesy of the Huntington Historical Society.)

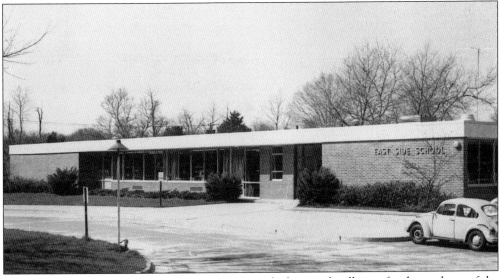

By the late 1940s, increased enrollment necessitated a larger schoolhouse for the students of the East Side. The voters approved the purchase of land on Goose Hill Road for a new school. In 1978, falling enrollments led to the closure of East Side School. Students went to either West Side School or Lloyd Harbor School. The district kept this building, and part of it was leased to the library until 2006. In 1993, the school was reopened as Goosehill Primary School, serving kindergarten and first grade. (Courtesy of the Cold Spring Harbor School District.)

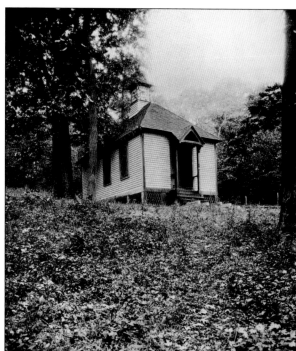

Henry Lloyd built a schoolhouse when he came to Lloyd Neck in 1711. Later, in the 19th century, a public school was built. Until 1885, Lloyd Neck was part of the Town of Oyster Bay and had its own school district. This building was constructed in 1908 to replace the earlier building. A dozen years later, Lloyd Neck children attended school on the "mainland." The school district sold the two acres on which this school sat to the state in the 1990s, and it is now part of Caumsett Historic Park. (Courtesy of the Huntington Historical Society.)

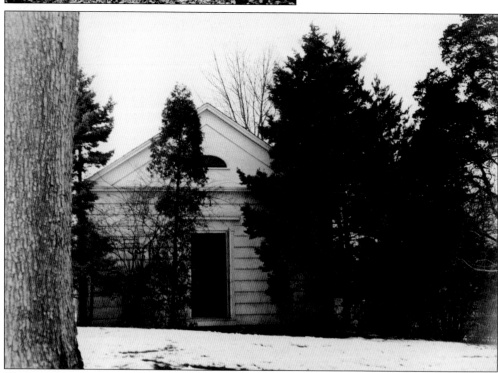

The area that is now the Lloyd Harbor Village Park was once the site of active brickyards and had a sizeable Irish immigrant population. Gilbert Crossman built this school in 1827 to educate the children of the brickyard workers. The school was closed in 1904, as was the West Neck School, which stood near Camel Hollow Road. (Courtesy of the Huntington Historical Society.)

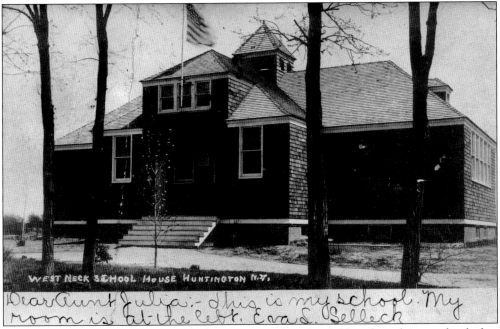

In 1904, a new four-room school was built to accommodate the children from the two schools that had been shut down by state education authorities that year. In 1920, children from Lloyd Neck were admitted as well. This schoolhouse stood adjacent to the site of the current Lloyd Harbor School. (Courtesy of the Huntington Historical Society.)

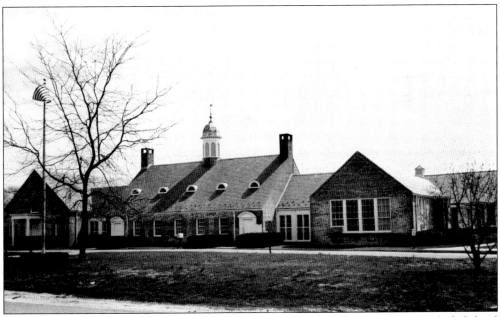

In 1933, the school district residents decided to buy five acres adjacent to the West Neck School and build a modern brick building. The new school welcomed 25 students when it was completed in 1935. The school has been enlarged numerous times over the past 75 years to accommodate its ever-growing enrollment. (Courtesy of the Cold Spring Harbor School District.)

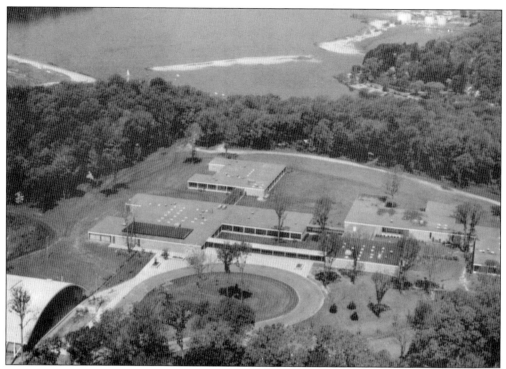

Prior to 1958, graduates of Cold Spring Harbor's three school districts attended Huntington High School or Oyster Bay High School. However, growing enrollments forced the Huntington School District to stop accepting out-of-district students. The residents of Laurel Hollow, Cold Spring Harbor, and Lloyd Harbor then voted to merge their three school districts and build their own high school. The new high school (above) opened in 1962. The class of 1964 was the first graduating class. (Above, courtesy of the Huntington Historical Society; below, courtesy of the Cold Spring Harbor School District.)

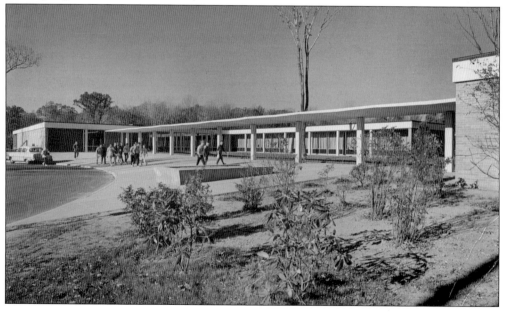

BIBLIOGRAPHY

Earle, Walter K. *Out of the Wilderness*. Cold Spring Harbor, NY: Cold Spring Harbor Whaling Museum Society, 1966.

Failey, Dean F. and Zachary N. Studenroth. *Edward Lange's Long Island*. Setauket, NY: Society for the Preservation of Long Island Antiquities, 1979.

Hunt, George P. *Tales of Old Lloyd Harbor*. Lloyd Harbor, NY: Village of Lloyd Harbor, 2001.

Jones, John Henry. *The Jones Family of Long Island: Descendants of Major Thomas Jones (1665–1726) and Allied Families*. New York: Tobias A. Wright, 1907.

MacKay, Robert B., et al. *Long Island Country Houses and Their Architects, 1860–1940*. New York: W.W. Norton & Company, 1997.

Murphy, Robert Cushman. *The Founding of the Whaling Museum at Cold Spring Harbor, L.I., N.Y.* Cold Spring Harbor, NY: Cold Spring Harbor Whaling Museum Society, 1967.

Norton, Margaret. *Maggie's Memories . . . A View of Cold Spring Harbor*. Cold Spring Harbor, NY: Rosalie Ink Publications, 2007.

Peckham, Leslie E. *Clamtown: Cold Spring Harbor, New York*. Cold Spring Harbor, NY: self-published, 1962.

Sammis, Romanah. *Huntington-Babylon Town History*. Huntington, NY: Huntington Historical Society, 1937.

Schmitt, Frederick P. *Mark Well The Whale*. Port Washington, NY: Kennikat Press, 1971.

Valentine, Harriet G. and Andrus T. *Main Street, Cold Spring Harbor*. Huntington, NY: Huntington Historical Society, 1960.

Valentine, Harriet G. *The Window to the Street*. Smithtown, NY: Exposition Press, Inc., 1981.

Various. *Cold Spring Harbor Soundings*. Cold Spring Harbor, NY: Cold Spring Harbor Village Improvement Society, 1953.

Various. *Cold Spring Harbor Fire Department 150th Anniversary Journal, 1852–2002*. Cold Spring Harbor, NY: Cold Spring Harbor Fire Department, 2003.

Walton, Terry. *Cold Spring Harbor: Rediscovering History in Streets and Shores*. Cold Spring Harbor, NY: Cold Spring Harbor Whaling Museum Society, 1999.

Watson, Elizabeth L. *Houses for Science: A Pictorial History of Cold Spring Harbor Laboratory*. Plainview, NY: Cold Spring Harbor Laboratory Press, 1991.

www.suffolkhistoricnewspapers.org